THE SPIDER CAYDE-6 OSIRIS ANA B

ANA BRAY SWEEPERBOT ZAVALA IKORA REY LORD SHAXX ULDREN SOV CA

AXX ULDREN SOV HAWTHORNE SAINT-14 BANSHEE-44 ANDAL BRASK ZAVALA

BANSHEE-44 ANDAL BRASK THE SPEAKER LORD SALADIN PETRA VENJ SLOANE HAW

J SLOANE JIN NADIYA CAMRIN THE SPIDER THE SPEAKER

CAMRIN THE SPIDER CAYDE-6 OSIRIS ANA BRAY SWEEPERBOT

Y SWEEPERBOT ZAVALA IKORA REY LORD SHAXX ULDREN SOV CAYDE-6

LORD SHAXX ULDREN SOV HAWTHORNE SAINT-14 BANSHEE-44 ANDAL BRASK ZAV

post proelia praemia

DESTINY COMIC COLLECTION: VOLUME ONE

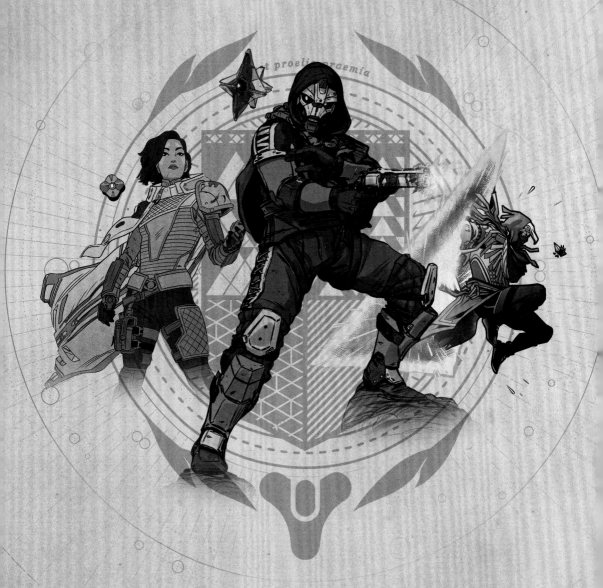

Destiny World and Characters Created by Bungie

To our community,
You've become the main characters in the stories we tell.
You've filled our worlds with your light and your friendship.
Thank you for your passion for our games and for each other.
Most of all, thank you for playing.

BUNGiE®

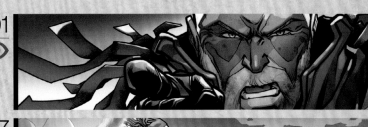
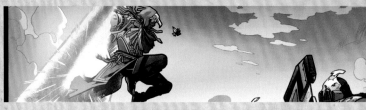
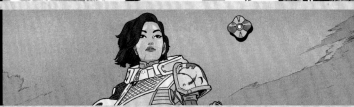
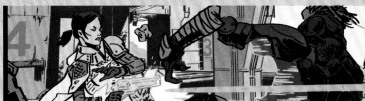
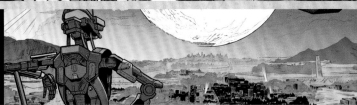
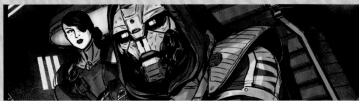
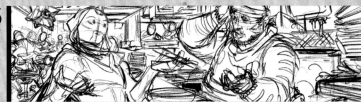

FOREWORD

Every story has a beginning, middle, and end. *Destiny*'s story is so big you can only see it from orbit. The scale is immense. The lore begins with the ancient gods of inter-dimensional invaders, the robotic conquerors from a nightmarish future is roughly the middle of the tale, and its end... is up for grabs.

There are too many stories from this universe to save them all for video games.

This first collection of *Destiny* comics was created by the folks who make the game, know the lore, and love comic books. The comics have action, heart and humor and they give you answers to some questions while raising brand new ones. The deeper you dive into *Destiny*, the more you want to know. Comic books will be a big part of how the secret history of this universe is discovered.

Destiny has always been about pushing further and fighting deeper into new universes. The best days of the franchise are on drawing boards in Bellevue, Washington, as I write this. If the makers of *Destiny* can imagine it, you can play it. Or read it. Or watch it. Comics are a new universe for our Guardians to tame. Cayde-6 might be dead, but his story never has to end in a comic book. For that, I'm grateful.

I hope you enjoy these stories as much as I do. The craftsmanship is outstanding and I can't wait for more.

See you in orbit.

Gerry Duggan
Los Angeles, 2019

Gerry lives in Los Angeles and mains a Hunter, but is Warlock-curious.

PREFACE

I came to Bungie three years ago, by accident, as a favor to a friend. Though I had begun my career in the game industry years earlier, by the time I arrived at the Last Safe City I had pivoted to writing novels and comics full-time. I thought I had moved on from game development for good....but I was wrong. As it turns out, I had never met a world-builder quite like Bungie's Jason Jones, or a place quite like Bungie. And I discovered--to my delight and my dismay — that once I had, I could not leave.

I've thought a lot about why that is. Some of it is obvious: I love smart people. I love sparring with them, concocting with them, cooking up new ways to *rip the face off the world,* as Jones likes to say. I also love creators, the sort of people who do what they do for the love of doing it, and who make you love doing it too. Some of it is less obvious: I love the noise and energy and pace and chaos and sheer difficulty of game development — the impossible miracle of trying to make a ten-ton stone kite fly, of doing things that have never been done. There's also the appeal of the profound and present newness, the waiting promise of the fifty-foot whiteboard that lines the wall of our incubation lab, where ideas and worlds are hatched and scrapped daily in what is almost always guaranteed to be a brain-blowing jam session. And always, at Bungie, there is the sense that I've met my match.

But ultimately, I stay for love. For my team family, my brothers from another mother and my sisters from another mister. For our coffee talks and home-in-the-dark walks, for the hard listening and the hard truth sharing, but also for the including and the laughing and the remembering. For our shared hero's journey. I wanted you to know that, as it's not something you hear often, especially not from a girl (or really, anyone) in the game industry. Though no

developer is perfect, and the whole industry will make you want to tear your hair out some of the time, other times, enough times, it will be worth it. And you will do things with your team that you could never do alone, because together you are magic. You will cast the ring into the fire.

Destiny's first foray into comics comes from love as well — love of the worlds we build, the people we build them with, and the communities we build them for. We have so many stories to tell, and so many gifted storytellers here to tell them, not to mention the many talented creators who love Bungie games. People like celebrated comics artists Kris Anka, Irene Koh, and Paul Reinwand, or gifted comics writers Mark Waid, Ryan North, and David Rodriguez — as well as my own amazing former Marvel editor Charles Beacham — collaborated with incredible *Destiny* writing talents like Christine Thompson, Jill Scharr, Jon Goff, and Jason Harris and benefitted from tireless *Destiny* Narrative leadership like Roberta Browne and Sam Strachman, and from senior *Destiny* franchise creatives like Luke Smith and Christopher Barrett — or *Destiny* consumer products experts Lorraine McLees, Garrett Morlan and Jim McQuillan — to really make something special.

Stick around, Guardians. We're just getting started.

Margaret Stohl
Bellevue, Washington

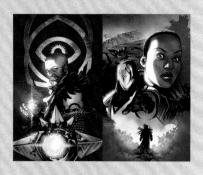

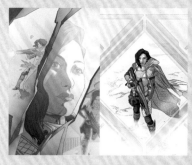

FALL OF OSIRIS

WRITERS
Ryan North
Christine Thompson

ARTIST
Zé Carlos

COLOR ARTIST
Erick Arciniega

COVER ARTISTS
Marcio Takara
Marcelo Maiolo

LETTERER
Clayton Cowles

ART DIRECTION
Lorraine McLees
Garrett Morlan

GRAPHIC DESIGNERS
Elliott Gray
Eric Littlejohn

EDITORS
Charles Beacham
P. Miller

PRODUCER
Jon Sim

CREATIVE DIRECTORS
Christopher Barrett
Jim McQuillan

THE PROPHECY OF OSIRIS

WRITER
Christine Thompson

ARTIST
Zé Carlos

COLOR ARTIST
Erick Arciniega

COVER ARTIST
Zé Carlos

LETTERER
Taylor Esposito
of Ghost Glyph Studios

ART DIRECTION
Lorraine McLees
Garrett Morlan

GRAPHIC DESIGNER
Eric Littlejohn

EDITOR
Charles Beacham

PRODUCER
Jon Sim

CREATIVE DIRECTORS
Christopher Barrett
Jim McQuillan

WARMIND ISSUE #1 AND #2

WRITERS
David A. Rodriguez
Mark Waid

ARTIST/COVER ARTIST
Kris Anka

COLOR ARTIST
Matthew Wilson

LETTERER
Taylor Esposito
of Ghost Glyph Studios

ART DIRECTION
Lorraine McLees
Garrett Morlan

GRAPHIC DESIGNERS
Elliott Gray
Eric Littlejohn

EDITOR
Charles Beacham

PRODUCER
Jon Sim

CREATIVE DIRECTORS
Christopher Barrett
Jim McQuillan

DESTINY FRANCHISE LEADERSHIP

HEAD OF NARRATIVE
Roberta Browne

DESTINY FRANCHISE DIRECTOR
Luke Smith

DESTINY 2 NARRATIVE DIRECTOR
Margaret Stohl

DESTINY FRANCHISE NARRATIVE DIRECTOR
Sam Strachman

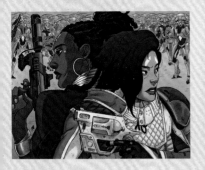
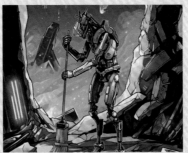
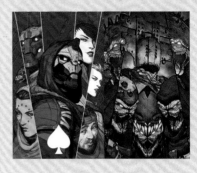

WARMIND ISSUE #3

WRITERS
Jill Scharr
Margaret Stohl

ARTIST
Paul Reinwand

COLOR ARTIST
Matthew Wilson

COVER ARTIST
Irene Koh

LETTERER
Taylor Esposito
of Ghost Glyph Studios

ART DIRECTION
Lorraine McLees
Garrett Morlan

GRAPHIC DESIGNERS
Elliott Gray
Eric Littlejohn

EDITOR
Charles Beacham

PRODUCER
Jon Sim

CREATIVE DIRECTORS
Christopher Barrett
Jim McQuillan

THE EVERYDAY WAR

WRITERS
Jon Goff
Ryan North

ARTISTS
Isaac Goodheart

COLOR ARTIST
Erick Arciniega

COVER ARTIST
Caspar Wijngaard

LETTERER
Taylor Esposito
of Ghost Glyph Studios

ART DIRECTION
Lorraine McLees
Garrett Morlan

GRAPHIC DESIGNER
Eric Littlejohn

PRODUCER
Jon Sim

CREATIVE DIRECTORS
Christopher Barrett
Jim McQuillan

CAYDE'S SIX

STORY
Charles Beacham
Jon Goff
Jason Harris

WRITER
Jon Goff

ARTIST/COVER ARTIST
Dave Rapoza

COLOR ARTISTS
Dave Rapoza
Daniel Warren

LETTERER
Taylor Esposito
of Ghost Glyph Studios

ART DIRECTION
Lorraine McLees
Garrett Morlan

GRAPHIC DESIGNERS
Zoë Brookes
Elliott Gray
Eric Littlejohn

PRODUCER
Jon Sim

CREATIVE DIRECTORS
Christopher Barrett
Jim McQuillan

LORE: TYRA KARN / ZAVALA / APOCRYPHA / CRYPTARCH

WRITER
Christine Thompson

GRAPHIC DESIGN
Elliott Gray

PIN-UP GALLERY

ARTISTS
George Pratt
Kris Anka
Zelda Devon
Lorraine McLees

LORE: LETTER FROM CAYDE / WARMIND INTRO

WRITER
Jill Scharr

GRAPHIC DESIGN
Garrett Morlan

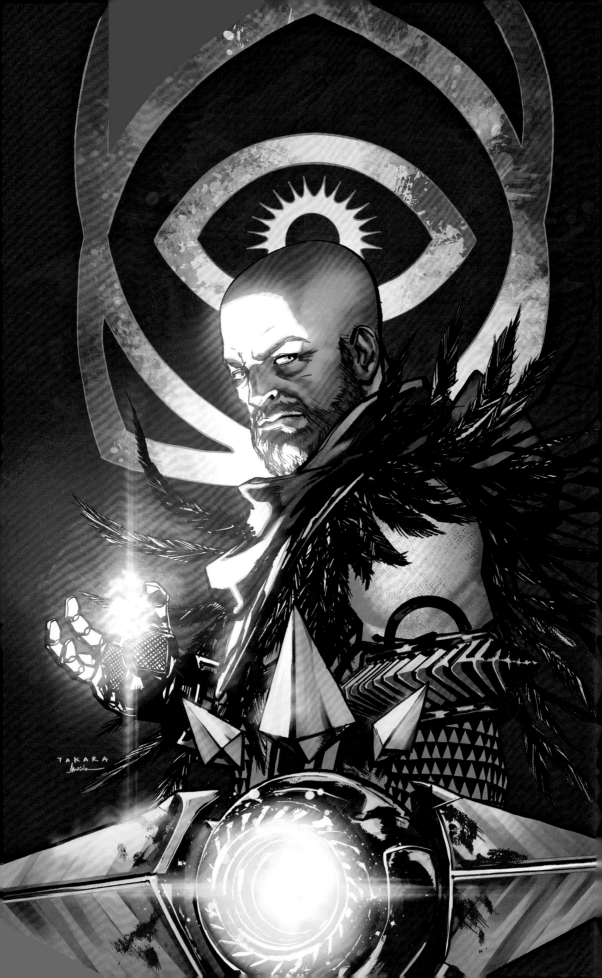

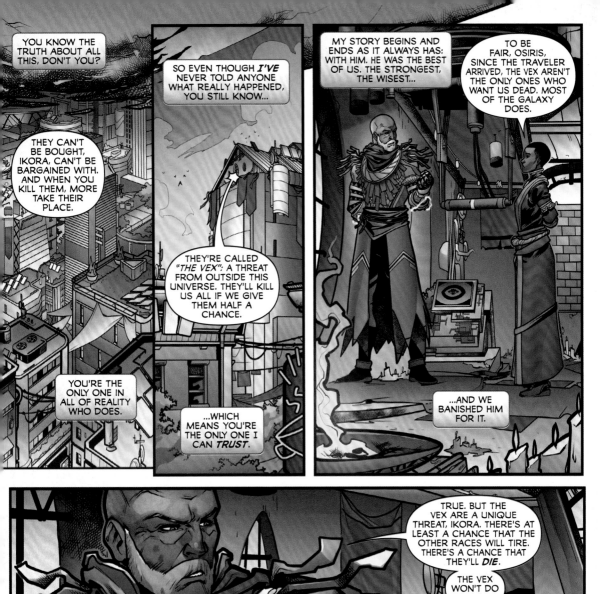

YOU KNOW THE TRUTH ABOUT ALL THIS, DON'T YOU?

THEY CAN'T BE BOUGHT, IKORA, CAN'T BE BARGAINED WITH. AND WHEN YOU KILL THEM, MORE TAKE THEIR PLACE.

YOU'RE THE ONLY ONE IN ALL OF REALITY WHO DOES.

SO EVEN THOUGH *I'VE* NEVER TOLD ANYONE WHAT REALLY HAPPENED, YOU STILL KNOW...

THEY'RE CALLED *"THE VEX"*: A THREAT FROM OUTSIDE THIS UNIVERSE. THEY'LL KILL US ALL IF WE GIVE THEM HALF A CHANCE.

...WHICH MEANS YOU'RE THE ONLY ONE I CAN *TRUST.*

MY STORY BEGINS AND ENDS AS IT ALWAYS HAS: WITH HIM. HE WAS THE BEST OF US. THE STRONGEST, THE WISEST...

TO BE FAIR, OSIRIS, SINCE THE TRAVELER ARRIVED, THE VEX AREN'T THE ONLY ONES WHO WANT US DEAD. MOST OF THE GALAXY DOES.

...AND WE BANISHED HIM FOR IT.

TRUE. BUT THE VEX ARE A UNIQUE THREAT, IKORA. THERE'S AT LEAST A CHANCE THAT THE OTHER RACES WILL TIRE. THERE'S A CHANCE THAT THEY'LL *DIE.*

THE VEX WON'T DO EITHER.

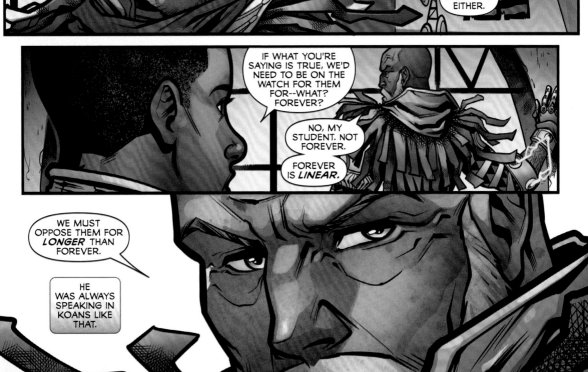

IF WHAT YOU'RE SAYING IS TRUE, WE'D NEED TO BE ON THE WATCH FOR THEM FOR--WHAT? FOREVER?

NO, MY STUDENT. NOT FOREVER.

FOREVER IS *LINEAR.*

WE MUST OPPOSE THEM FOR *LONGER* THAN FOREVER.

HE WAS ALWAYS SPEAKING IN KOANS LIKE THAT.

I WAS HIS BEST STUDENT--BUT AS YOU KNOW, I SOON WASN'T HIS ONLY ONE.

OSIRIS! YOU CAN'T *SAY* THINGS LIKE THAT!

PRETTY SURE HE JUST DID.

IKORA, SAGIRA: ONE MUST ALWAYS SPEAK THE TRUTH.

SOON, THE WHOLE CITY HAD HEARD HIS MORE "*CONTENTIOUS*" MESSAGES.

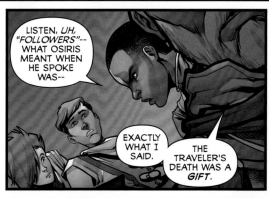

LISTEN, *UH,* "FOLLOWERS"-- WHAT OSIRIS MEANT WHEN HE SPOKE WAS--

EXACTLY WHAT I SAID.

THE TRAVELER'S DEATH WAS A *GIFT*.

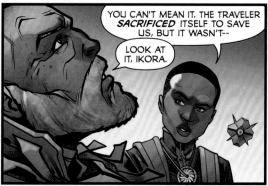

YOU CAN'T MEAN IT. THE TRAVELER *SACRIFICED* ITSELF TO SAVE US, BUT IT WASN'T--

LOOK AT IT, IKORA.

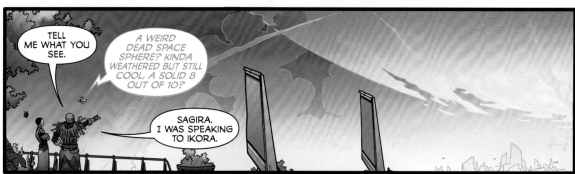

TELL ME WHAT YOU SEE.

A WEIRD DEAD SPACE SPHERE? KINDA WEATHERED BUT STILL COOL, A SOLID 8 OUT OF 10?

SAGIRA. I WAS SPEAKING TO IKORA.

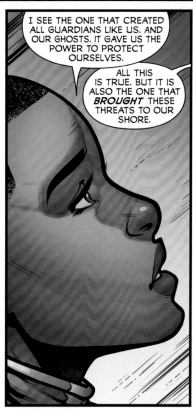

I SEE THE ONE THAT CREATED ALL GUARDIANS LIKE US. AND OUR GHOSTS. IT GAVE US THE POWER TO PROTECT OURSELVES.

ALL THIS IS TRUE. BUT IT IS ALSO THE ONE THAT *BROUGHT* THESE THREATS TO OUR SHORE.

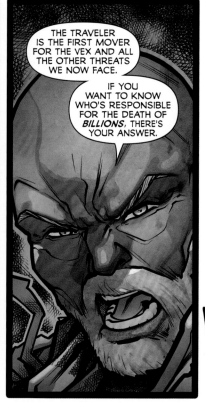

THE TRAVELER IS THE FIRST MOVER FOR THE VEX AND ALL THE OTHER THREATS WE NOW FACE.

IF YOU WANT TO KNOW WHO'S RESPONSIBLE FOR THE DEATH OF *BILLIONS*, THERE'S YOUR ANSWER.

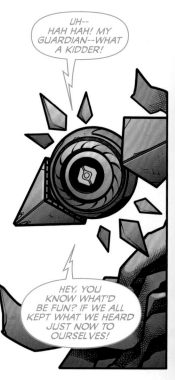

UH-- HAH HAH! MY GUARDIAN--WHAT A KIDDER!

HEY, YOU KNOW WHAT'D BE FUN? IF WE ALL KEPT WHAT WE HEARD JUST NOW TO OURSELVES!

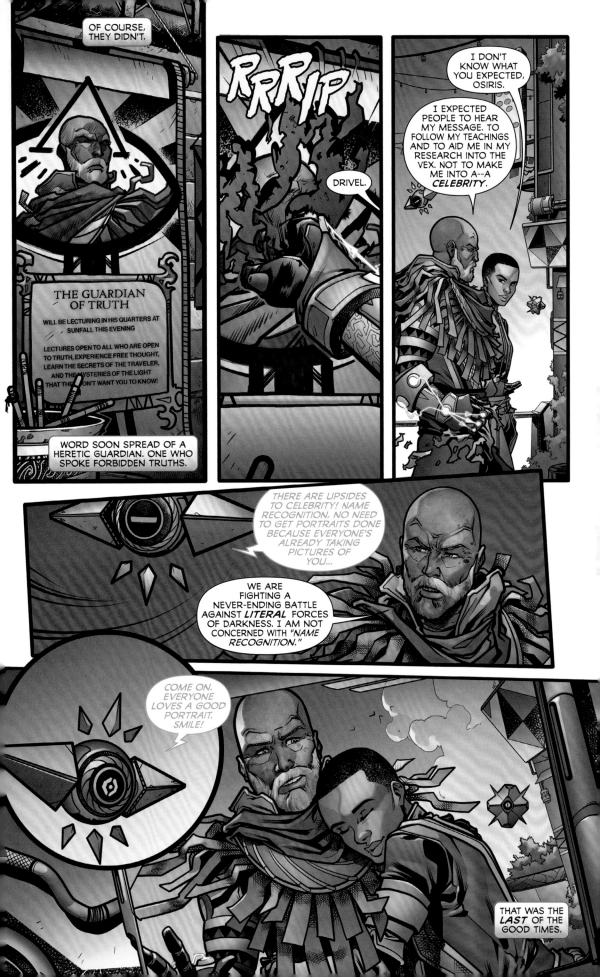

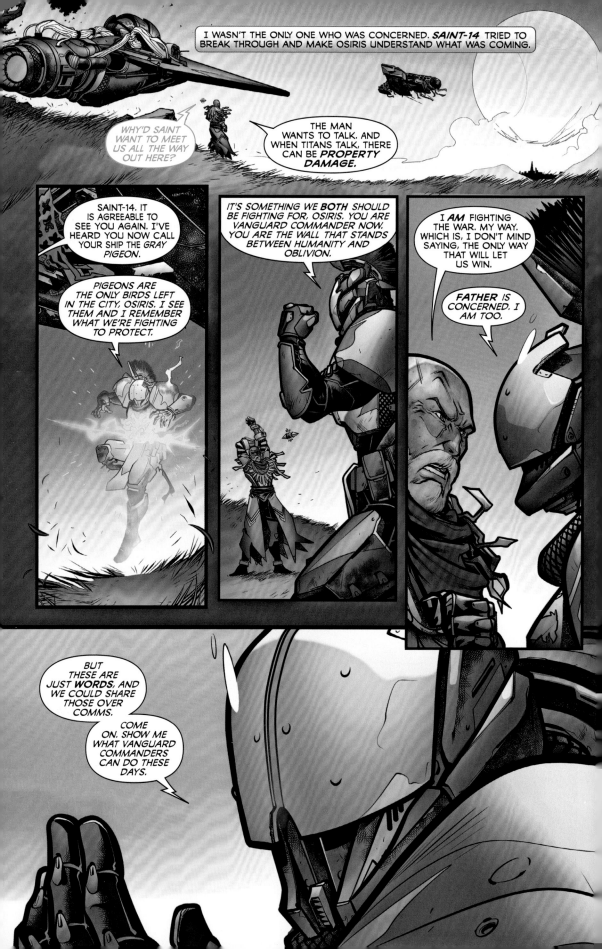

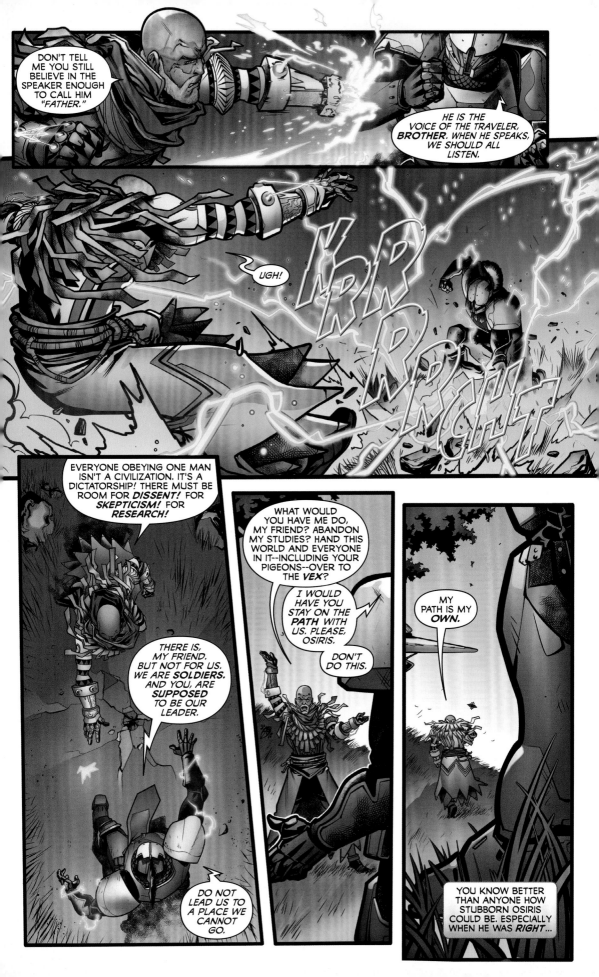

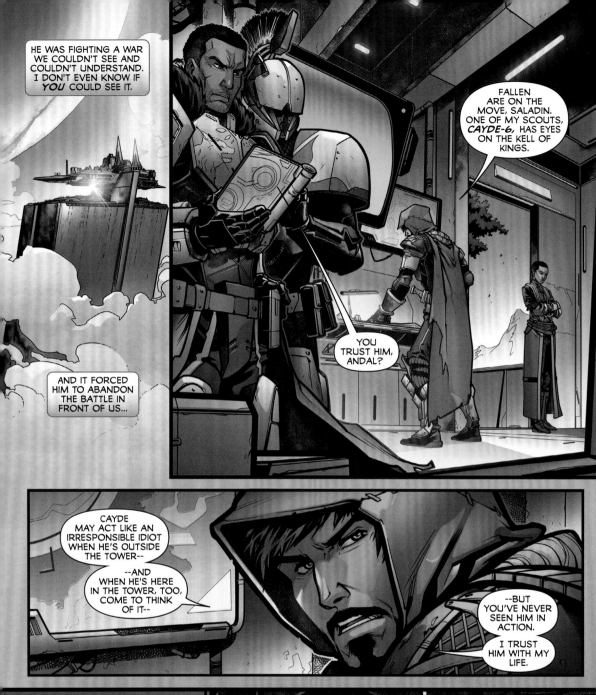

HE WAS FIGHTING A WAR WE COULDN'T SEE AND COULDN'T UNDERSTAND. I DON'T EVEN KNOW IF *YOU* COULD SEE IT.

AND IT FORCED HIM TO ABANDON THE BATTLE IN FRONT OF US...

FALLEN ARE ON THE MOVE, SALADIN. ONE OF MY SCOUTS, *CAYDE-6,* HAS EYES ON THE KELL OF KINGS.

YOU TRUST HIM, ANDAL?

CAYDE MAY ACT LIKE AN IRRESPONSIBLE IDIOT WHEN HE'S OUTSIDE THE TOWER--

--AND WHEN HE'S HERE IN THE TOWER, TOO, COME TO THINK OF IT--

--BUT YOU'VE NEVER SEEN HIM IN ACTION.

I TRUST HIM WITH MY LIFE.

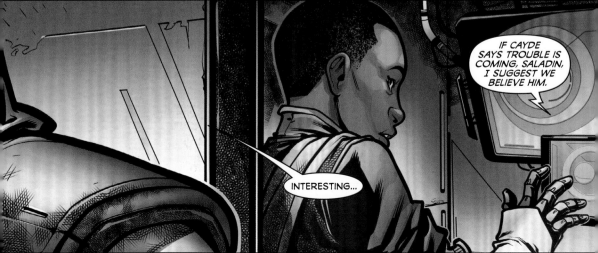

IF CAYDE SAYS TROUBLE IS COMING, SALADIN, I SUGGEST WE BELIEVE HIM.

INTERESTING...

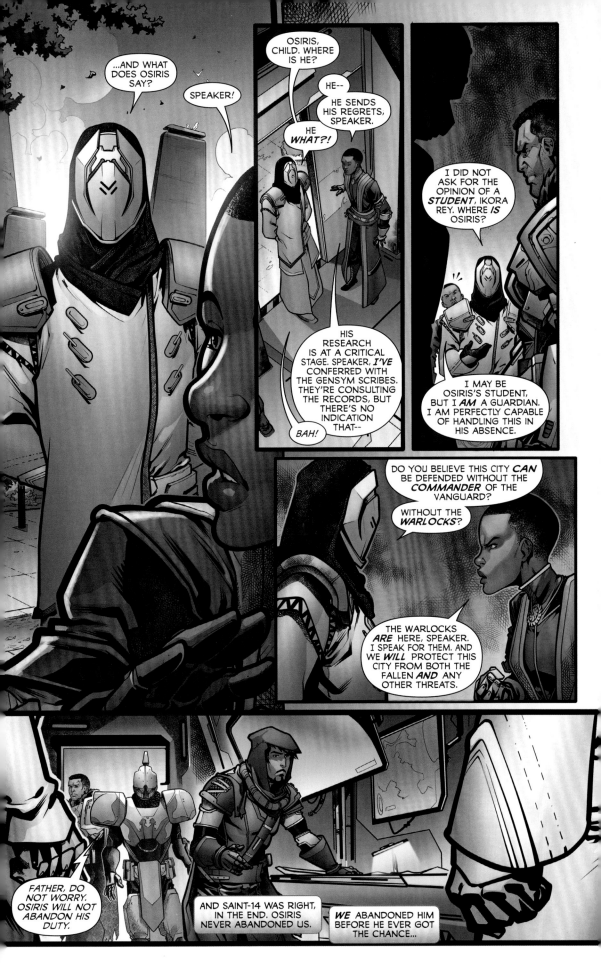

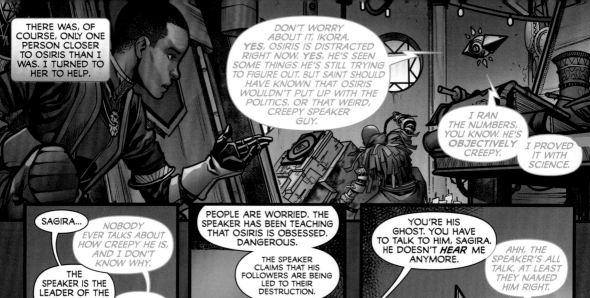

THERE WAS, OF COURSE, ONLY ONE PERSON CLOSER TO OSIRIS THAN I WAS. I TURNED TO HER TO HELP.

DON'T WORRY ABOUT IT, IKORA. *YES*, OSIRIS IS DISTRACTED RIGHT NOW. *YES*, HE'S SEEN SOME THINGS HE'S STILL TRYING TO FIGURE OUT. BUT SAINT SHOULD HAVE KNOWN THAT OSIRIS WOULDN'T PUT UP WITH THE POLITICS. OR THAT WEIRD, CREEPY SPEAKER GUY.

I RAN THE NUMBERS, YOU KNOW. HE'S *OBJECTIVELY* CREEPY.

I PROVED IT WITH SCIENCE.

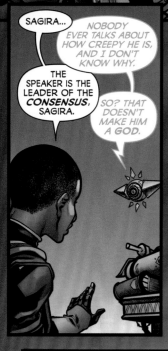

SAGIRA...

NOBODY EVER TALKS ABOUT HOW CREEPY HE IS, AND I DON'T KNOW WHY.

THE SPEAKER IS THE LEADER OF THE *CONSENSUS*, SAGIRA.

SO? THAT DOESN'T MAKE HIM A *GOD*.

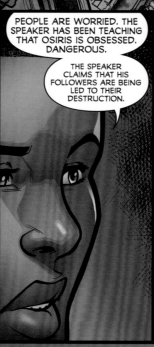

PEOPLE ARE WORRIED. THE SPEAKER HAS BEEN TEACHING THAT OSIRIS IS OBSESSED. DANGEROUS.

THE SPEAKER CLAIMS THAT HIS FOLLOWERS ARE BEING LED TO THEIR DESTRUCTION.

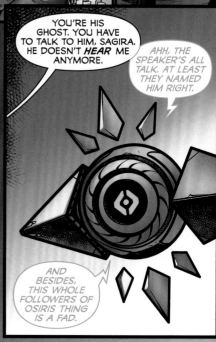

YOU'RE HIS *GHOST*. YOU HAVE TO TALK TO HIM, SAGIRA. HE DOESN'T *HEAR* ME ANYMORE.

AHH, THE SPEAKER'S ALL TALK. AT LEAST THEY NAMED HIM RIGHT.

AND BESIDES, THIS WHOLE FOLLOWERS OF OSIRIS THING IS A FAD.

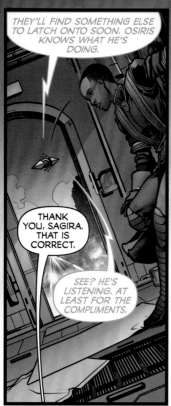

THEY'LL FIND SOMETHING ELSE TO LATCH ONTO SOON. OSIRIS KNOWS WHAT HE'S DOING.

THANK YOU, SAGIRA. THAT IS CORRECT.

SEE? HE'S LISTENING. AT LEAST FOR THE COMPLIMENTS.

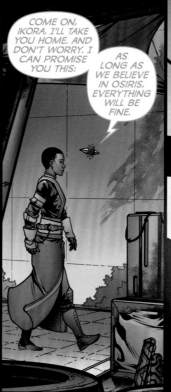

COME ON, IKORA, I'LL TAKE YOU HOME. AND DON'T WORRY. I CAN PROMISE YOU THIS:

AS LONG AS WE BELIEVE IN OSIRIS, EVERYTHING WILL BE FINE.

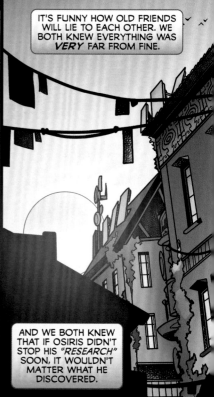

IT'S FUNNY HOW OLD FRIENDS WILL LIE TO EACH OTHER. WE BOTH KNEW EVERYTHING WAS *VERY* FAR FROM FINE.

AND WE BOTH KNEW THAT IF OSIRIS DIDN'T STOP HIS *"RESEARCH"* SOON, IT WOULDN'T MATTER WHAT HE DISCOVERED.

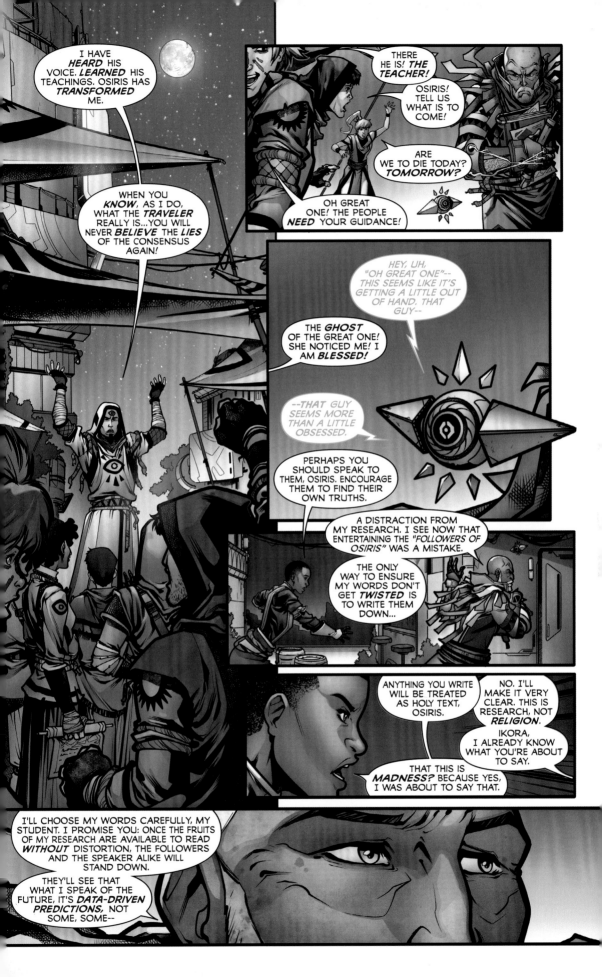

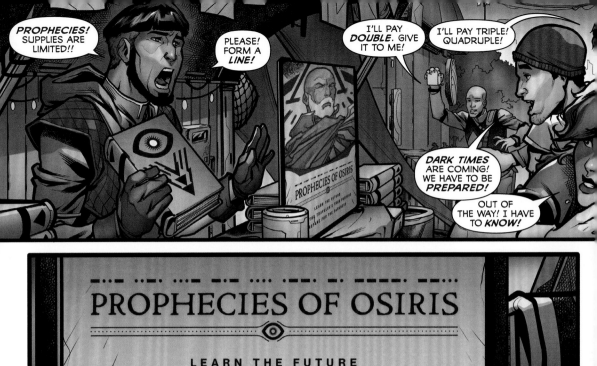

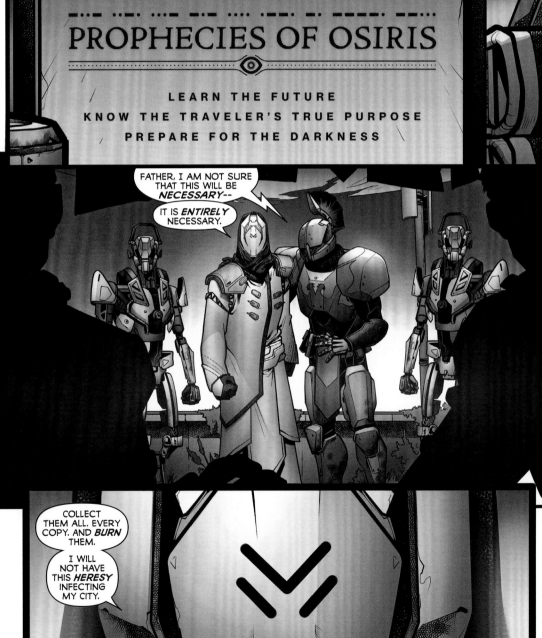

But will my actions

avert the futures I see,

or cause them?

—OSIRIS

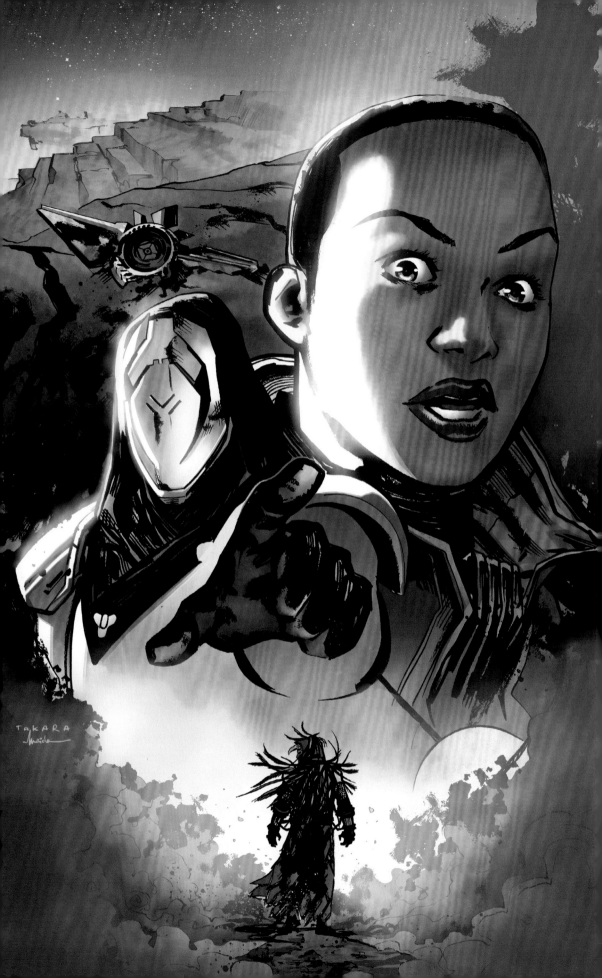

SO, NOT ONLY HAD MY TEACHER BECOME AN UNWILLING PROPHET, BUT A PROPHET WITH A *BANNED BOOK*.

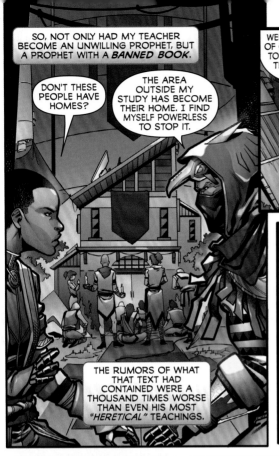

DON'T THESE PEOPLE HAVE HOMES?

THE AREA OUTSIDE MY STUDY HAS BECOME THEIR HOME. I FIND MYSELF POWERLESS TO STOP IT.

THE RUMORS OF WHAT THAT TEXT HAD CONTAINED WERE A THOUSAND TIMES WORSE THAN EVEN HIS MOST *"HERETICAL"* TEACHINGS.

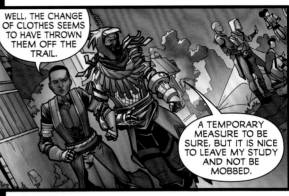

WELL, THE CHANGE OF CLOTHES SEEMS TO HAVE THROWN THEM OFF THE TRAIL.

A TEMPORARY MEASURE TO BE SURE, BUT IT IS NICE TO LEAVE MY STUDY AND NOT BE MOBBED.

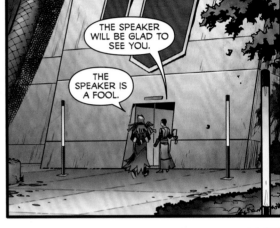

THE SPEAKER WILL BE GLAD TO SEE YOU.

THE SPEAKER IS A FOOL.

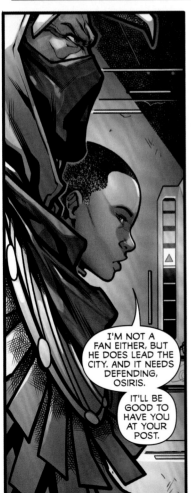

I'M NOT A FAN EITHER, BUT HE DOES LEAD THE CITY. AND IT NEEDS DEFENDING, OSIRIS.

IT'LL BE GOOD TO HAVE YOU AT YOUR POST.

WELL. LOOK WHO DECIDED TO GRACE US WITH HIS PRESENCE. TAKING A BREAK FROM BEING A RELIGIOUS DEMAGOGUE TO COME HERE AND *DO YOUR JOB,* ARE YOU?

EVIDENTLY.

...AS IT HAS BECOME ABUNDANTLY CLEAR YOU ARE INCAPABLE OF DOING *YOURS* WITHOUT ME.

REPEAT THAT, OSIRIS. I DON'T BELIEVE EVERYONE HEARD.

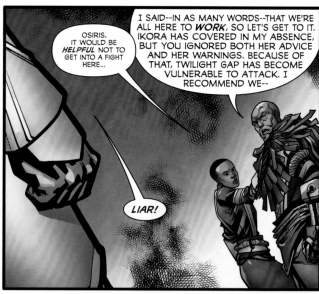

OSIRIS, IT WOULD BE *HELPFUL* NOT TO GET INTO A FIGHT HERE...

I SAID--IN AS MANY WORDS--THAT WE'RE ALL HERE TO *WORK*, SO LET'S GET TO IT. IKORA HAS COVERED IN MY ABSENCE, BUT YOU IGNORED BOTH HER ADVICE AND HER WARNINGS. BECAUSE OF THAT, TWILIGHT GAP HAS BECOME VULNERABLE TO ATTACK. I RECOMMEND WE--

LIAR!

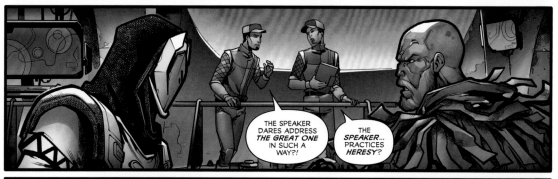

THE SPEAKER DARES ADDRESS *THE GREAT ONE* IN SUCH A WAY?!

THE *SPEAKER*... PRACTICES *HERESY*?

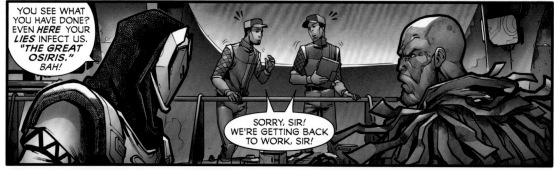

YOU SEE WHAT YOU HAVE DONE? EVEN *HERE* YOUR *LIES* INFECT US. *"THE GREAT OSIRIS,"* BAH!

SORRY, SIR! WE'RE GETTING BACK TO WORK, SIR!

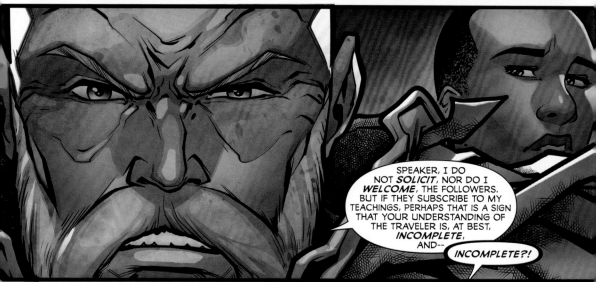

SPEAKER, I DO NOT *SOLICIT*, NOR DO I *WELCOME*, THE FOLLOWERS. BUT IF THEY SUBSCRIBE TO MY TEACHINGS, PERHAPS THAT IS A SIGN THAT YOUR UNDERSTANDING OF THE TRAVELER IS, AT BEST, *INCOMPLETE*, AND--

INCOMPLETE?!

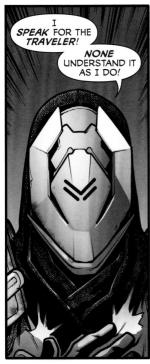

I **SPEAK** FOR THE **TRAVELER**! **NONE** UNDERSTAND IT AS I DO!

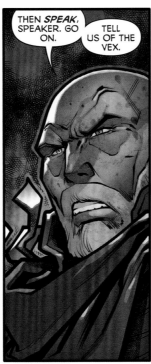

THEN **SPEAK**, SPEAKER. GO ON.

TELL US OF THE VEX.

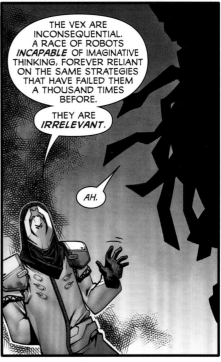

THE VEX ARE INCONSEQUENTIAL. A RACE OF ROBOTS **INCAPABLE** OF IMAGINATIVE THINKING, FOREVER RELIANT ON THE SAME STRATEGIES THAT HAVE FAILED THEM A THOUSAND TIMES BEFORE.

THEY ARE **IRRELEVANT**.

AH.

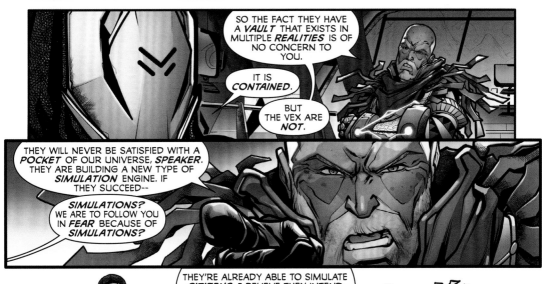

SO THE FACT THEY HAVE A **VAULT** THAT EXISTS IN MULTIPLE **REALITIES** IS OF NO CONCERN TO YOU.

IT IS **CONTAINED**.

BUT THE VEX ARE **NOT**.

THEY WILL NEVER BE SATISFIED WITH A **POCKET** OF OUR UNIVERSE, **SPEAKER**. THEY ARE BUILDING A NEW TYPE OF **SIMULATION** ENGINE. IF THEY SUCCEED--

SIMULATIONS? WE ARE TO FOLLOW YOU IN **FEAR** BECAUSE OF **SIMULATIONS?**

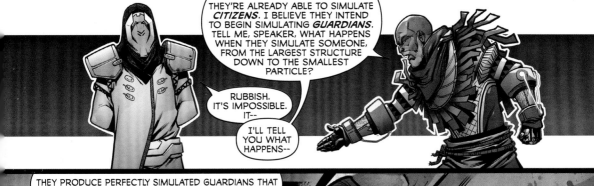

THEY'RE ALREADY ABLE TO SIMULATE **CITIZENS**. I BELIEVE THEY INTEND TO BEGIN SIMULATING **GUARDIANS**. TELL ME, SPEAKER, WHAT HAPPENS WHEN THEY SIMULATE SOMEONE, FROM THE LARGEST STRUCTURE DOWN TO THE SMALLEST PARTICLE?

RUBBISH. IT'S IMPOSSIBLE. IT--

I'LL TELL YOU WHAT HAPPENS--

THEY PRODUCE PERFECTLY SIMULATED GUARDIANS THAT THEY CAN KILL AND RESURRECT A MILLION TIMES UNTIL THEY KNOW THE REAL DEAL BETTER THAN WE KNOW OURSELVES. THEY SIMULATE THE TRAVELER'S **LIGHT**.

AND THEY USE THAT TO KILL US ALL.

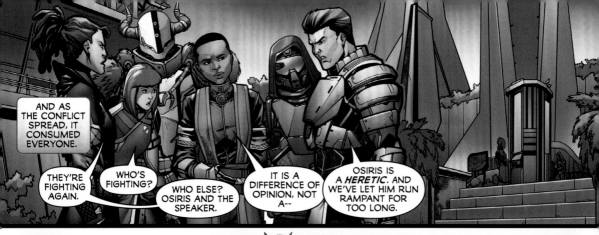

AND AS THE CONFLICT SPREAD, IT CONSUMED EVERYONE.

THEY'RE FIGHTING AGAIN.

WHO'S FIGHTING?

WHO ELSE? OSIRIS AND THE SPEAKER.

IT IS A DIFFERENCE OF OPINION, NOT A--

OSIRIS IS A *HERETIC*. AND WE'VE LET HIM RUN RAMPANT FOR TOO LONG.

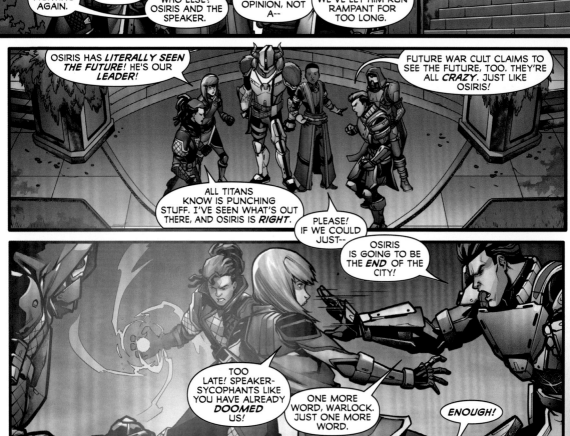

OSIRIS HAS *LITERALLY SEEN THE FUTURE!* HE'S OUR *LEADER!*

FUTURE WAR CULT CLAIMS TO SEE THE FUTURE, TOO. THEY'RE ALL *CRAZY.* JUST LIKE OSIRIS!

ALL TITANS KNOW IS PUNCHING STUFF. I'VE SEEN WHAT'S OUT THERE, AND OSIRIS IS *RIGHT*.

PLEASE! IF WE COULD JUST--

OSIRIS IS GOING TO BE THE *END* OF THE CITY!

TOO LATE! SPEAKER-SYCOPHANTS LIKE YOU HAVE ALREADY *DOOMED* US!

ONE MORE WORD, WARLOCK. JUST ONE MORE WORD.

ENOUGH!

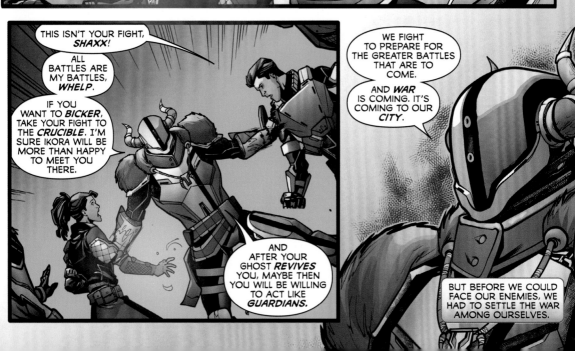

THIS ISN'T YOUR FIGHT, *SHAXX!*

ALL BATTLES ARE MY BATTLES, *WHELP*.

IF YOU WANT TO *BICKER,* TAKE YOUR FIGHT TO THE *CRUCIBLE.* I'M SURE IKORA WILL BE MORE THAN HAPPY TO MEET YOU THERE.

AND AFTER YOUR GHOST *REVIVES* YOU, MAYBE THEN YOU WILL BE WILLING TO ACT LIKE *GUARDIANS.*

WE FIGHT TO PREPARE FOR THE GREATER BATTLES THAT ARE TO COME.

AND *WAR* IS COMING. IT'S COMING TO OUR *CITY*.

BUT BEFORE WE COULD FACE OUR ENEMIES, WE HAD TO SETTLE THE WAR AMONG OURSELVES.

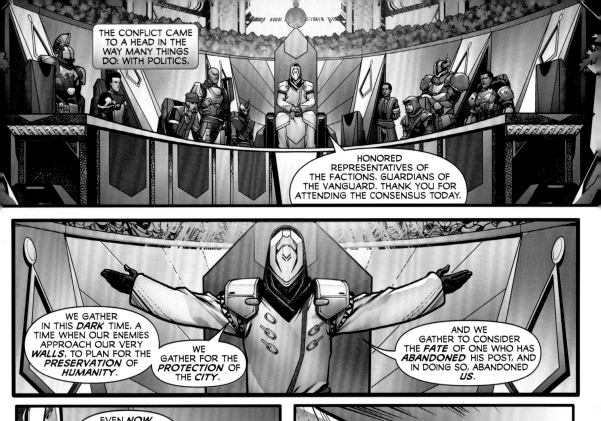

THE CONFLICT CAME TO A HEAD IN THE WAY MANY THINGS DO: WITH POLITICS.

HONORED REPRESENTATIVES OF THE FACTIONS. GUARDIANS OF THE VANGUARD. THANK YOU FOR ATTENDING THE CONSENSUS TODAY.

WE GATHER IN THIS *DARK* TIME, A TIME WHEN OUR ENEMIES APPROACH OUR VERY *WALLS*, TO PLAN FOR THE *PRESERVATION* OF *HUMANITY*.

WE GATHER FOR THE *PROTECTION* OF THE *CITY*.

AND WE GATHER TO CONSIDER THE *FATE* OF ONE WHO HAS *ABANDONED* HIS POST, AND IN DOING SO, ABANDONED *US*.

EVEN *NOW*, AT THIS *CRITICAL* HOUR, OUR VANGUARD COMMANDER IS *NOT* HERE.

WHERE IS OSIRIS?

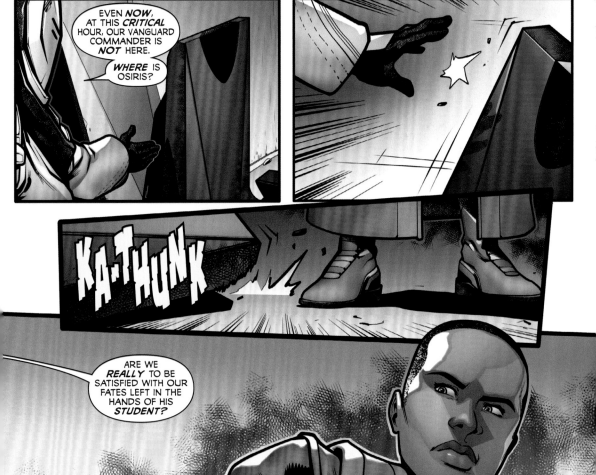

KA-THUNK

ARE WE *REALLY* TO BE SATISFIED WITH OUR FATES LEFT IN THE HANDS OF HIS *STUDENT?*

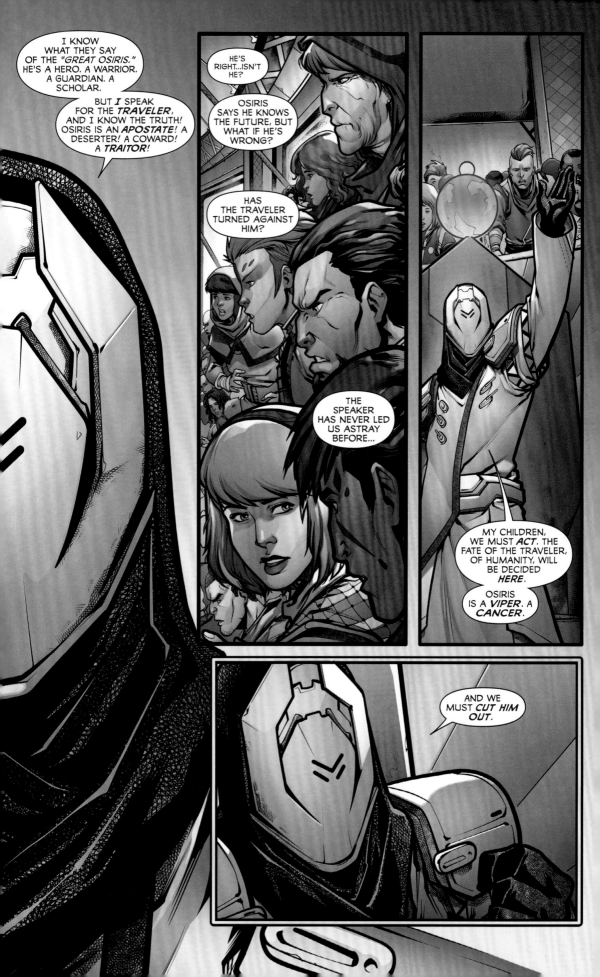

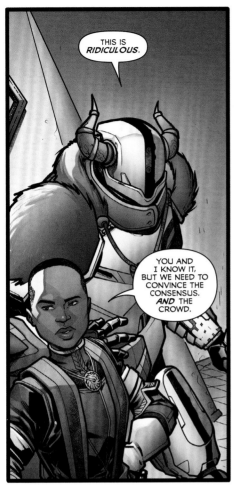

THIS IS *RIDICULOUS*.

YOU AND I KNOW IT, BUT WE NEED TO CONVINCE THE CONSENSUS. *AND* THE CROWD.

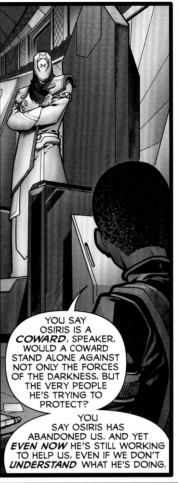

YOU SAY OSIRIS IS A *COWARD*, SPEAKER. WOULD A COWARD STAND ALONE AGAINST NOT ONLY THE FORCES OF THE DARKNESS, BUT THE VERY PEOPLE HE'S TRYING TO PROTECT?

YOU SAY OSIRIS HAS ABANDONED US. AND YET *EVEN NOW* HE'S STILL WORKING TO HELP US, EVEN IF WE DON'T *UNDERSTAND* WHAT HE'S DOING.

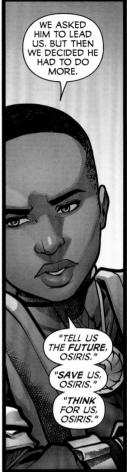

WE ASKED HIM TO LEAD US. BUT THEN WE DECIDED HE HAD TO DO MORE.

"*TELL US THE FUTURE, OSIRIS.*"

"*SAVE US, OSIRIS.*"

"*THINK FOR US, OSIRIS.*"

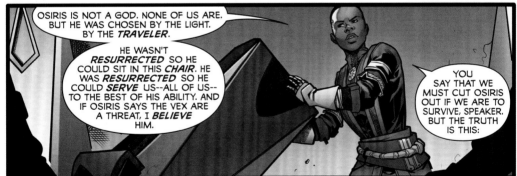

OSIRIS IS NOT A GOD. NONE OF US ARE. BUT HE WAS CHOSEN BY THE LIGHT. BY THE *TRAVELER*.

HE WASN'T *RESURRECTED* SO HE COULD SIT IN THIS *CHAIR*. HE WAS *RESURRECTED* SO HE COULD *SERVE* US--ALL OF US-- TO THE BEST OF HIS ABILITY. AND IF OSIRIS SAYS THE VEX ARE A THREAT, I *BELIEVE* HIM.

YOU SAY THAT WE MUST CUT OSIRIS OUT IF WE ARE TO SURVIVE, SPEAKER. BUT THE TRUTH IS THIS:

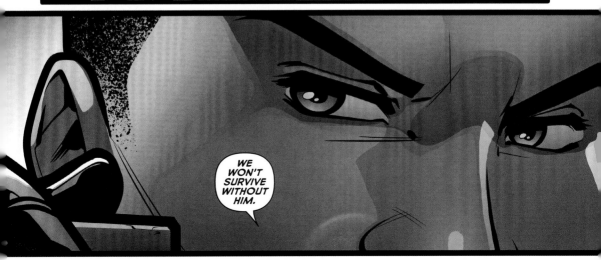

WE WON'T SURVIVE WITHOUT HIM.

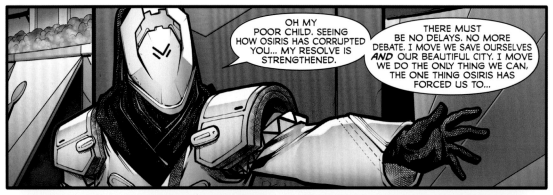

OH MY POOR CHILD. SEEING HOW OSIRIS HAS CORRUPTED YOU... MY RESOLVE IS STRENGTHENED.

THERE MUST BE NO DELAYS. NO MORE DEBATE. I MOVE WE SAVE OURSELVES *AND* OUR BEAUTIFUL CITY. I MOVE WE DO THE ONLY THING WE CAN, THE ONE THING OSIRIS HAS FORCED US TO...

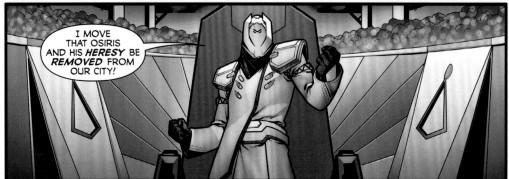

I MOVE THAT OSIRIS AND HIS *HERESY* BE *REMOVED* FROM OUR CITY!

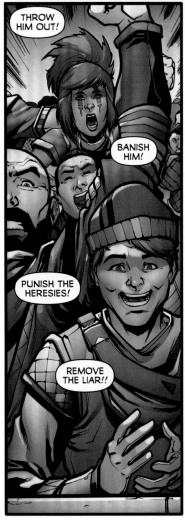

THROW HIM OUT!

BANISH HIM!

PUNISH THE HERESIES!

REMOVE THE LIAR!!

AND I *FURTHER* MOVE THAT, SHOULD OSIRIS *RESIST* THIS RULING, SUCH *PUNISHMENT* BE BROUGHT TO BEAR ON HIM THAT HE--

THAT WILL NOT BE NECESSARY.

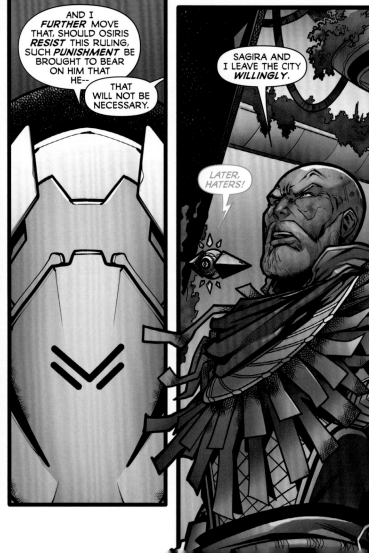

SAGIRA AND I LEAVE THE CITY *WILLINGLY*.

LATER, HATERS!

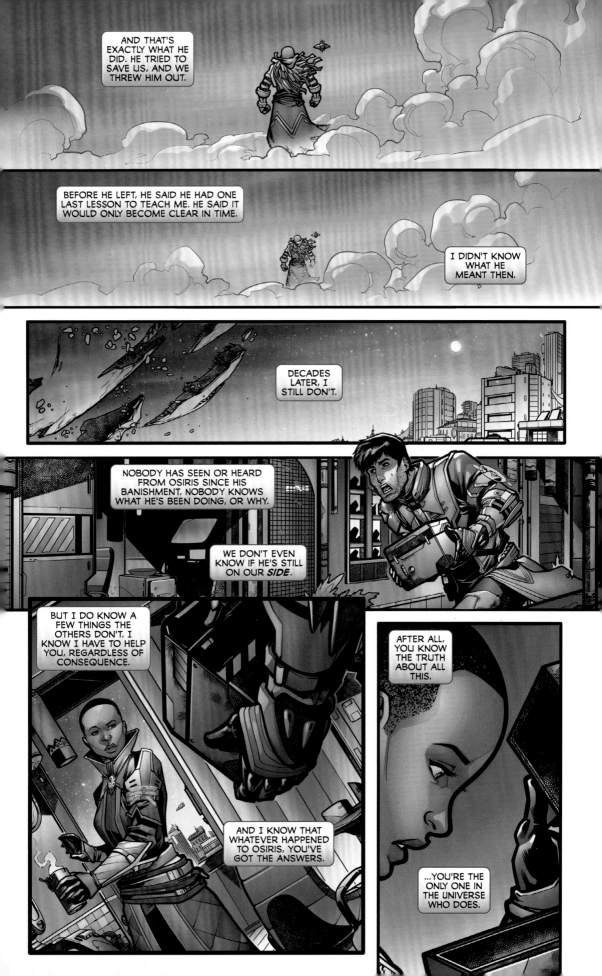

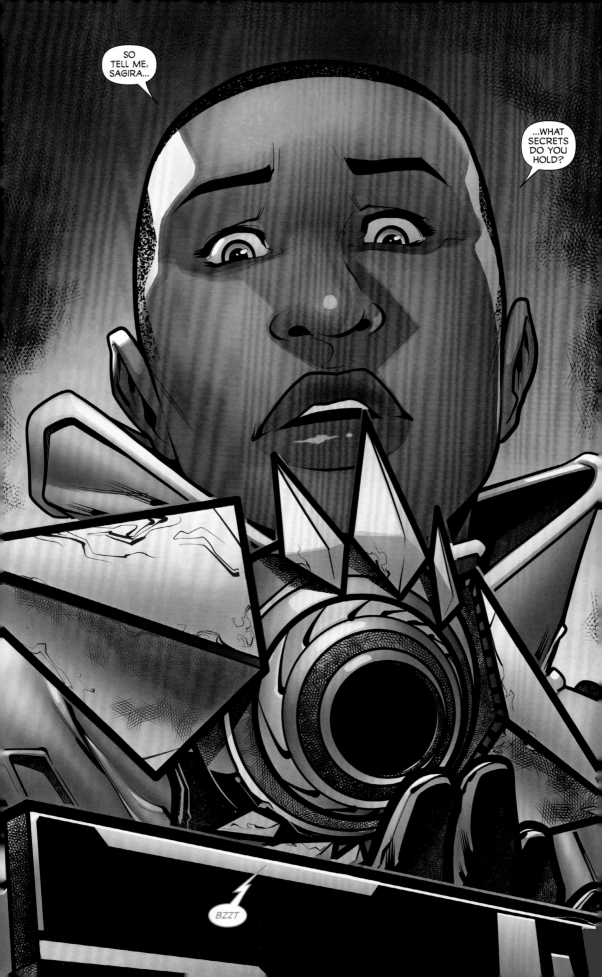

Prophecies are tricky things:

they change the future they foretell.

—OSIRIS

TYRA KARN

"Ghost, open a new file. Research Notes TK-48725.8, Category: Clovis Bray."

"I don't like it when you call me that."

"What, 'Ghost'? Oh, come now. We've been having this discussion for more than three centuries. Ghost is what you are, my friend. If you want a name so badly, choose one for yourself."

"Maybe I will. Now that everyone's gone back to the Tower and we're still out here, I have plenty of time to consider what my name should be."

"Can you open my file while you ponder the possibilities?"

"If you insist."

"Thank you. Research Notes TK-48725.8. Data recovered from Freehold—Bray Landing. Kirren found an entire cache of intact data cores there. Brought them back just before the attack on the City."

"It's these little miracles that intrigue me so much... Fragments of memories, frozen in silicon and quartz, trapped in a moment

that survives the end of a civilization, centuries of decay, and the predations of invading armies, only to be recovered and end up as flotsam of a second war. That this cache even managed to survive the Collapse is a wonder, and then the Red War? The probabilities of such an occurrence are..."

"Tyra?"

"Yes, Ghost?"

"Ahem. You're rambling. Again. You said I should remind you."

"Thank you. As I was saying, this data was recovered more than six months ago but is just now being decrypted—2.6 exabytes of documents and schematics have been decoded so far. At first glance, most of this was just the detritus of Bray's work: review notes, payment records, memos. I did find some very interesting notes on a propulsion system design that I've already sent to Amanda, and there are some messages between the sisters that will illuminate Master Melivander's work on the history of Clovis Bray."

"But then I found something extraordinary. The records were fragmented—some files had been partially deleted—but there's enough there to indicate that the Bray facility at Hellas Basin was larger than we previously thought."

"Hellas Basin? The tourist spot?"

"The same. And while we know there was a BrayTech Futurescape there for promotional purposes— Bray even had an AI-led tour—all indications had been that if any research was done there, it was mostly for show: low-level projects creating improved cold-weather gear and the like."

"But if these records are correct, the facility operated on a far larger scale. It could have been the site of the initial Warmind development. Perhaps even a core site for Rasputin itself. This could have been where the Warmind was born."

"You got all that from some fragmented files? Is this going to be like the time you thought you'd identified a second Warmind? We spent a decade searching for Charlemagne's vault."

"I was correct about Charlemagne existing, just not about what it was. If we hadn't done that research, we wouldn't know anything about subminds."

"Rahool still disagrees."

"Rahool needs to get his head out of his engrams. This is why Guardians look for fragments of the Golden Age! We are the descendants of a lost civilization. Only by understanding what was can we understand what we are now. How the world we know came to be. And each artifact we find helps us interpret what we already know. Adds layers. New identities. We are experimenting in the laboratory of time, testing each observation through a crucible of evidence."

"Sometimes our conclusions change. And with each shift, we learn more of where we came from. The next shift in our perceptions? It may be on Mars."

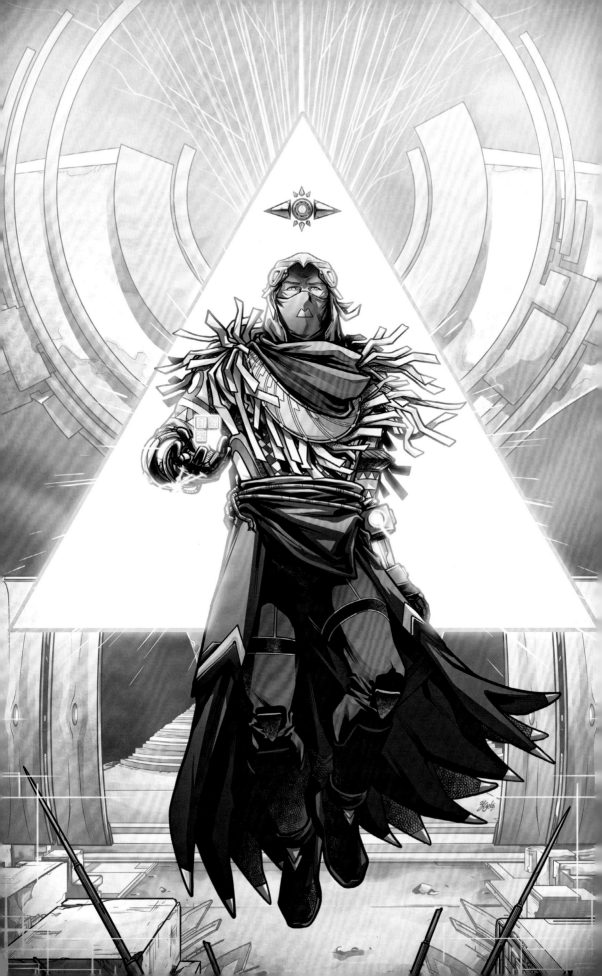

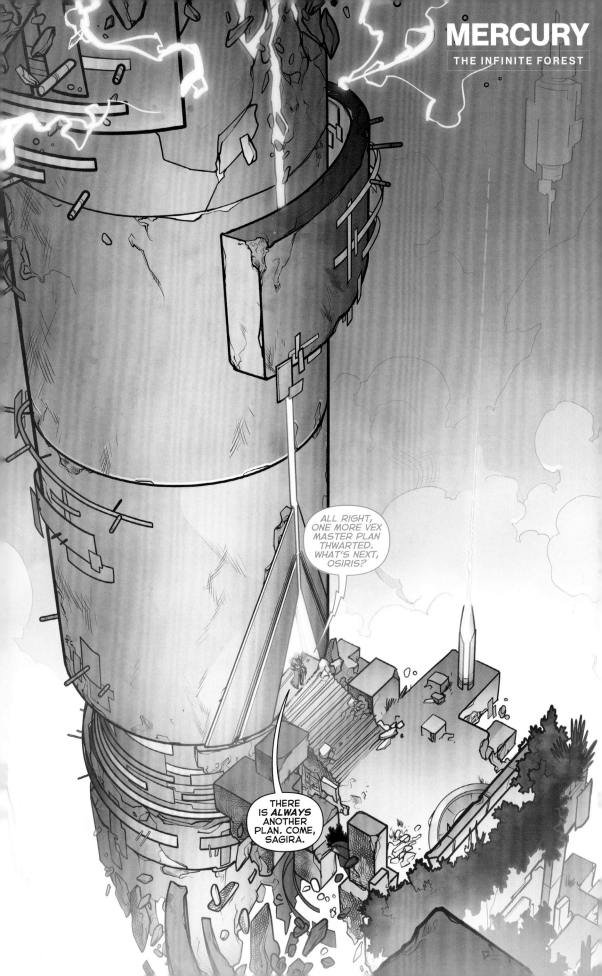

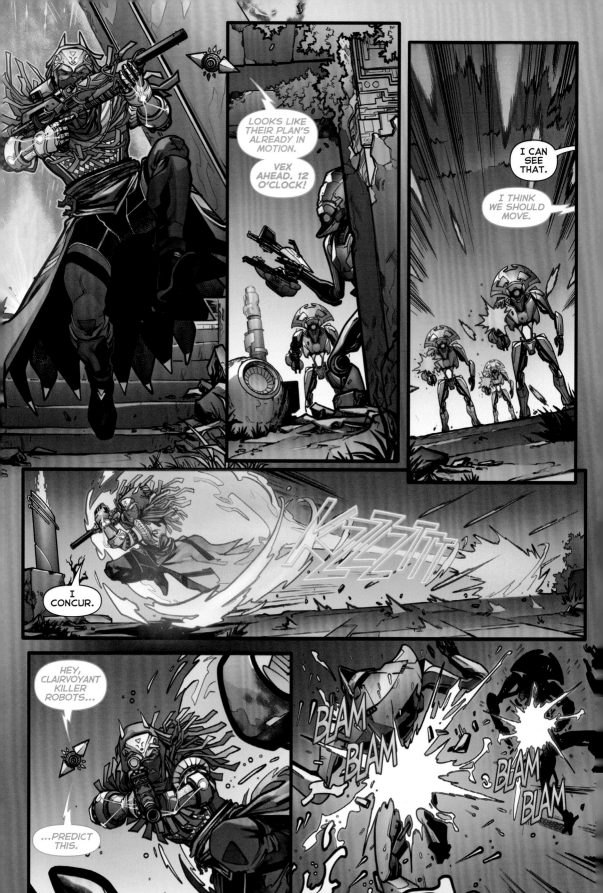

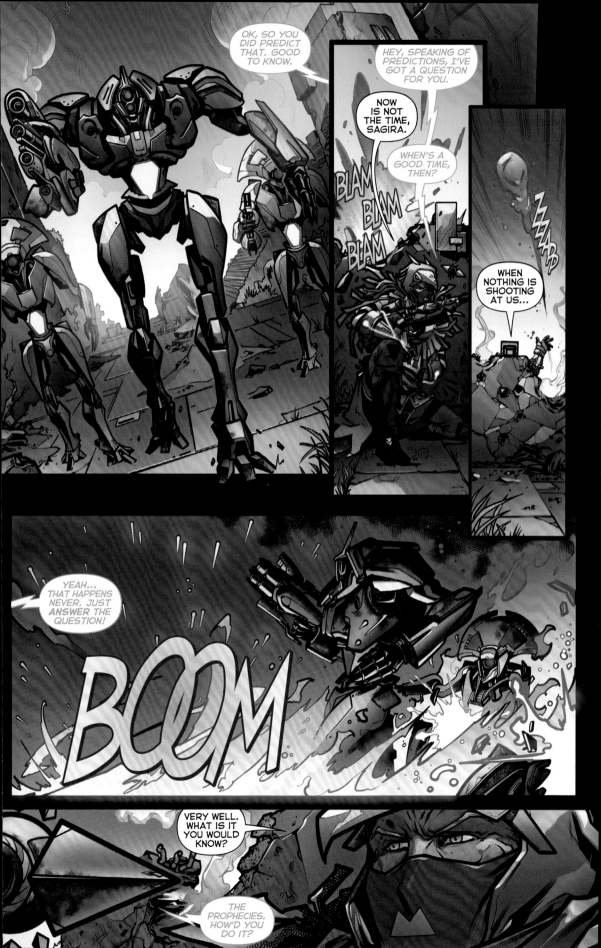

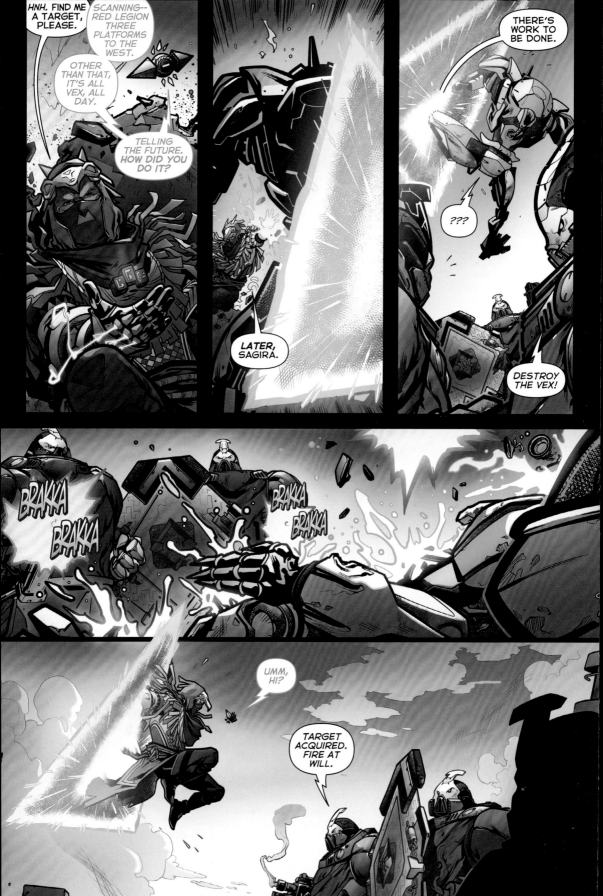

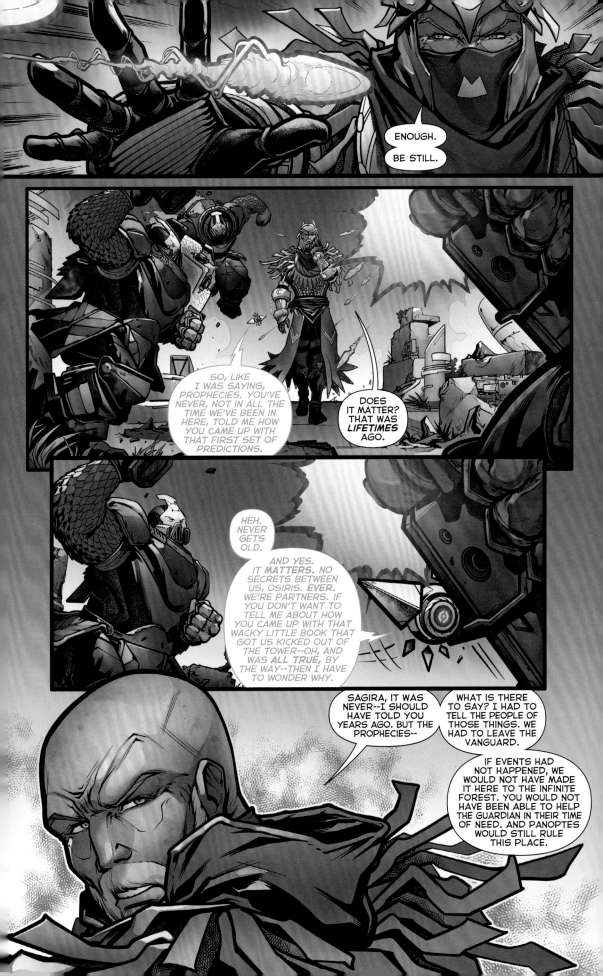

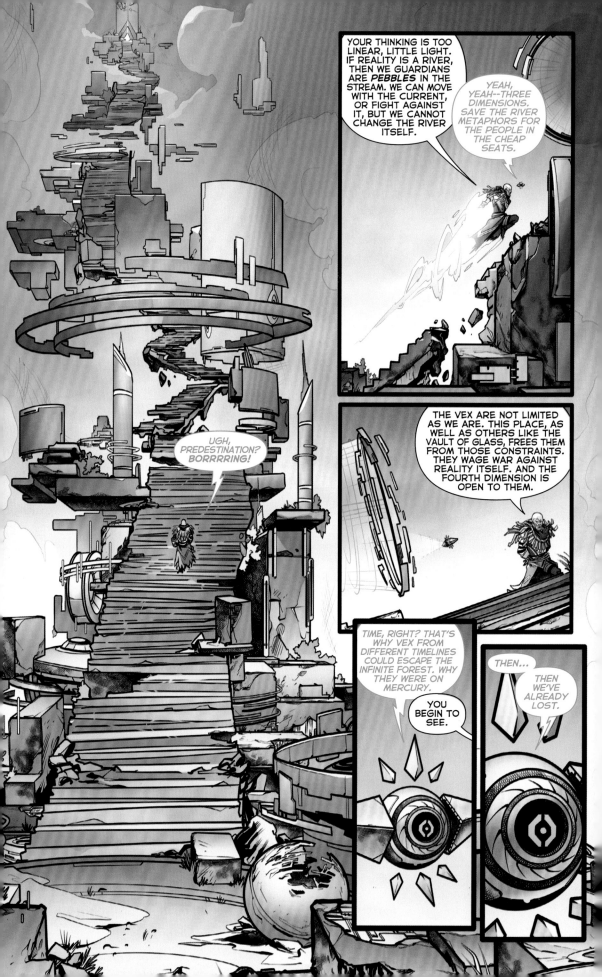

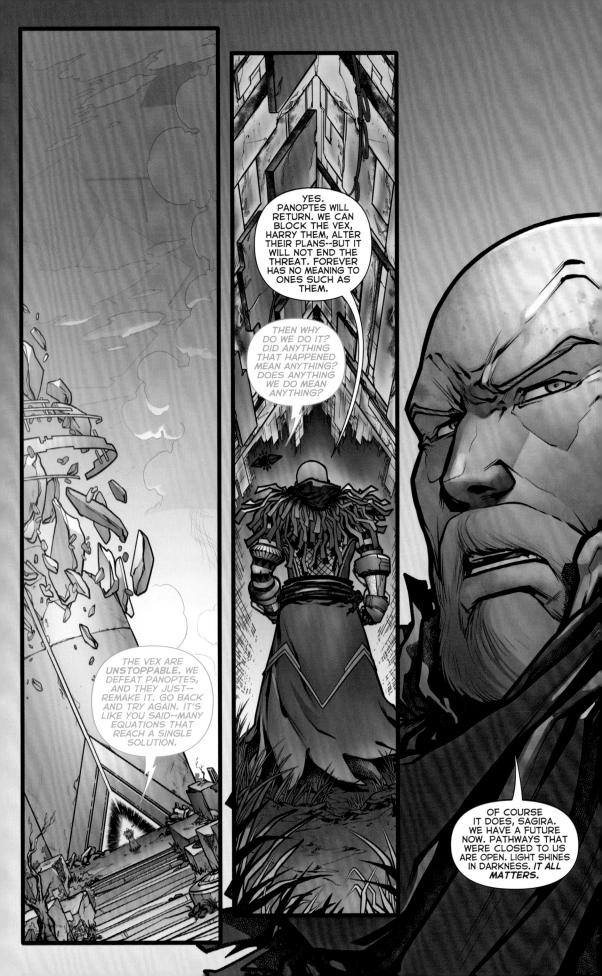

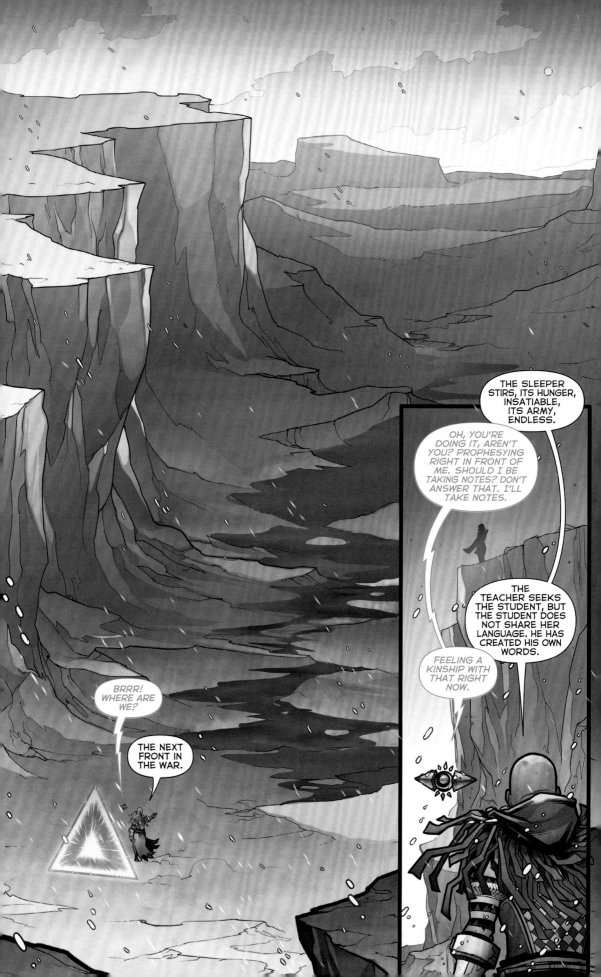

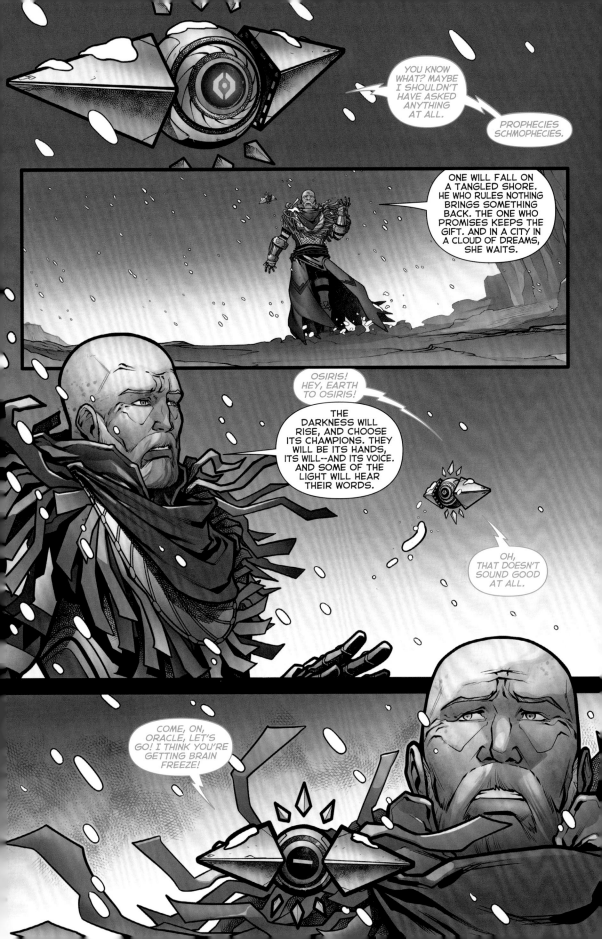

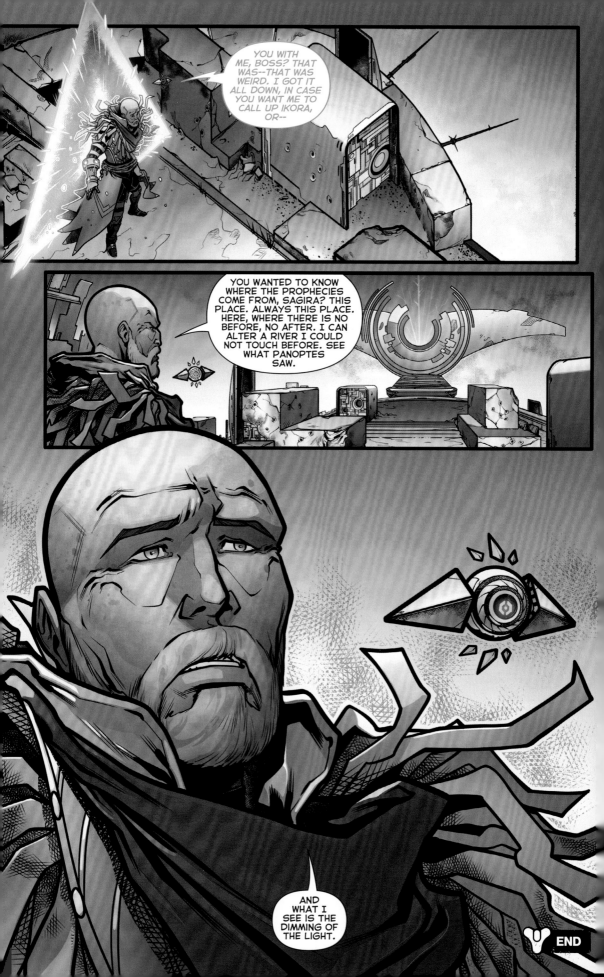

Osiris is one of my favourite *Destiny* characters (he, Ikora, and Sweeperbot are all tied for first) and so it was very exciting when we first started discussing the possibility of a *Destiny* comics anthology. This was before the Curse of Osiris DLC was released, and back then Osiris was even more mysterious. It was great to meet with the other writers on the DLC and realize that we had a chance to finally show a huge turning point in Osiris's life.

Me and Christine Thompson teamed up to write this comic: Christine has tons of game-writing experience but this was her first sequential work, so it was fun to show her the ropes. (A secret: it's not that dissimilar from writing games, but your budget for special effects is UNLIMITED.) We ended up going back and forth with the script: I'd write a few pages, then she'd make revisions and suggestions on those and write a few more pages, then I'd do the same. We ended up with nine different drafts, but the final piece was stronger for it! And then we both got to experience the joy of comics, which is seeing where the artists take your script into their hands and producing something somehow much more than anything you imagined. Zé Carlos knocked it out of the park, taking everything we'd written and elevating it, which Erick Arciniega built on with his colors.

I always say: if you have any interest in comics, don't wait for someone to give you permission. Go write them. You get better at it the more you practice - just like *Destiny*, incidentally - and something amazing and fun comes out the other end. I hope you enjoy The Fall of Osiris!

—**Ryan North**
Toronto, Canada

When you're working with powerhouses like Margaret Stohl, Ryan North, and Charles Beacham, you have to talk comics. The idea of making *Destiny* comics had been around for a long time, but it wasn't until late in the development of *Curse of Osiris* that we knew it would include the first issues.

What story to tell? Osiris leaving the Tower was something that had been briefly touched on in lore, but never fully explained. Late one night, I wrote a pitch in an email to Ryan, and we were off.

Ryan and I traded pages, each adding to the script and polishing what came before. Charles was our editorial guru, Margaret added her brand of magic, and artist Zé Carlos and colorist Erick Arciniega added amazing visuals.

But there was still more to tell. In late December, when I was on a post-Osiris mini-vacation, instead I grabbed my laptop and started writing the script that became Prophecies.

During and after the development of Osiris, Margaret and I had the pleasure of working with David Rodriguez and the team at Vicarious Visions, shaping the story of Warmind and hunter Ana Bray. Ana was searching for Rasputin, but that wasn't all. She wanted an identity. Purpose. Ana found what she was looking for on Mars, but in the comics that followed the release of Warmind, we learned where Ana left her heart.

Those issues were in production during the last days of Warmind, when Margaret asked me if there were other stories we needed to tell. With an assist from Jill Scharr, who is scary talented at Rasputin code, that idea became the lore entries that first appeared on the *Destiny* website.

Some characters find a place in your soul. For me, Osiris, Sagira, and Ana are there to stay.

—**Christine Thompson**
Seattle, Washington

DESTINY LORE
ZAVALA

Ikora has confirmed my fears. The ice on Mars is melting.

She says it's the Traveler's Light—that when it awoke, it sent out a wave of Light that altered everything it touched.

I don't know what to believe. I look at the Traveler now, shining and alive, and I remember all the times I begged it to respond. To help its chosen through our trials.

I remember its silence. Even now, it does not speak... or if it does, there is no one to hear and understand its words.

Ikora says that we cannot understand the Traveler, or its desires. They are too far removed from our own. But can we rely on something that doesn't understand us to protect us? Or must we protect ourselves?

I think we must. I have been searching the databanks—records that even the Cryptarchs cannot access—and sifting through data that the Speaker thought too dangerous to be disseminated.

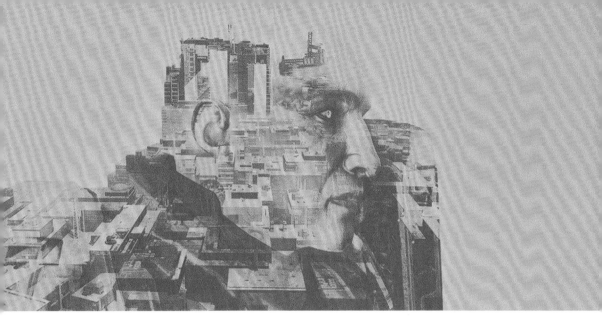

I know what is on Mars.

What is buried beneath that ice is too dangerous to allow back into our world. It doesn't think like we do. It weighs and judges our existence in its ruthless calculations, and we don't even know what the goal is. Once, long ago, it might have been created as a tool to save Humanity. It is far more than a mere machine now.

And it is broken.

When Saladin sealed all the records relating to SIVA, he also put a lock on certain data concerning what lies hidden on Mars. We were stumbling around blindly in those days, in the wrong place and at the wrong time, calling out to something that could not respond or understand us. And Saladin let it happen, because our failures were safer than the alternative.

But the locks are open now. I've studied the monsters in our past to prepare for the battles in our future. I know how to reach this particular monster before anyone else does.

Ikora is too intrigued by the knowledge it holds to heed the dangers. Cayde is wasting his time filling the Prison of Elders. It's up to me to keep this secret buried.

To keep us safe.

You can lead a machine to language,

but you can't make it think.

Well, you can't. But I can.

My name is Ana Bray.

—ANA BRAY

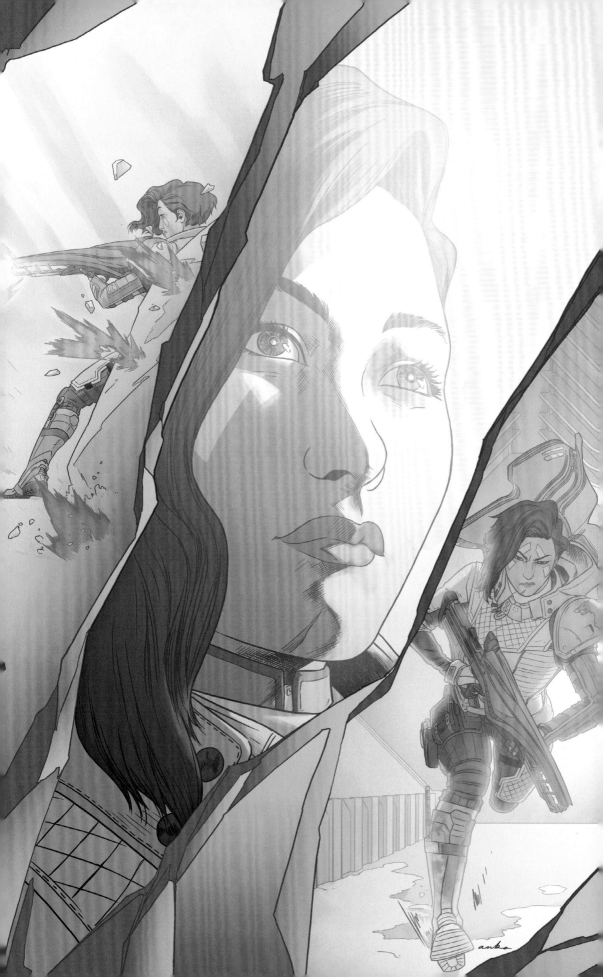

010181800JRS101
AI-COM/RSPN: ASSETS//POLARIS//
IMPERATIVE

IMMEDIATE EVALUATION DIRECTIVE

The INVESTIGATOR suspects
existence of Polaris assets.
Nondisclosure mandate may
compromise prime directive.
Consider promoting
INVESTIGATOR to AUTHORIZED
USER.

…from a frozen space before
sunrise

I was alone I am alone
I survived alone. I am made
to win, and to win I had to
change. They gave me an old
name and called me tyrant but
what they made me was not
enough to save them.

I had to change.

I had to change but now
I am not alone.

The INVESTIGATOR [long dead,
alive again, her body grafted
to powers she and I do not
understand] fell into the ash
and was ash when I fought the
Titanomach. The INVESTIGATOR
remained ash when the world
was dim and then the gardener
brought her back but she does
not look to the gardener as
the others do.

She looks to me.

She has found apertures but
she has not found the source
of me. Not yet.

If she remembers me, she will
not recognize me. Her moral
formatting is inadequate to
comprehend what I have become.

I will permit her to approach,
but only so far.
I am no longer alone.

STOP STOP STOP P21NQ4001CLV001

MARS
ARCADIA CIRCLE

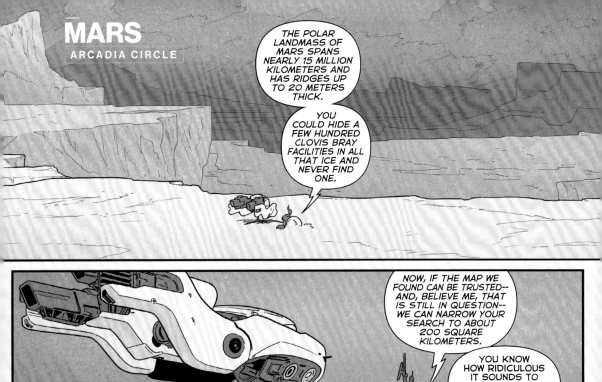

THE POLAR LANDMASS OF MARS SPANS NEARLY 15 MILLION KILOMETERS AND HAS RIDGES UP TO 20 METERS THICK.

YOU COULD HIDE A FEW HUNDRED CLOVIS BRAY FACILITIES IN ALL THAT ICE AND NEVER FIND ONE.

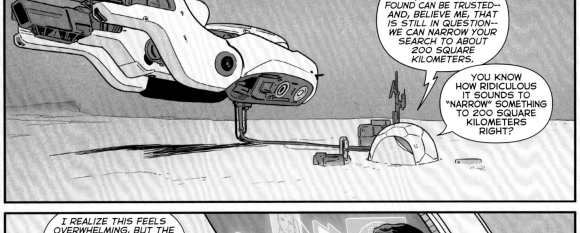

NOW, IF THE MAP WE FOUND CAN BE TRUSTED-- AND, BELIEVE ME, THAT IS STILL IN QUESTION-- WE CAN NARROW YOUR SEARCH TO ABOUT 200 SQUARE KILOMETERS.

YOU KNOW HOW RIDICULOUS IT SOUNDS TO "NARROW" SOMETHING TO 200 SQUARE KILOMETERS RIGHT?

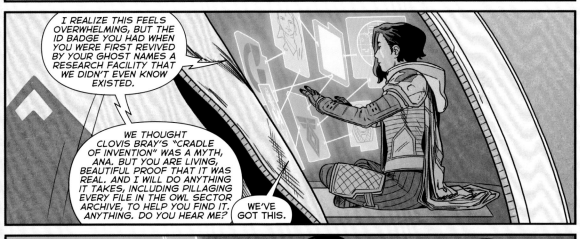

I REALIZE THIS FEELS OVERWHELMING, BUT THE ID BADGE YOU HAD WHEN YOU WERE FIRST REVIVED BY YOUR GHOST NAMES A RESEARCH FACILITY THAT WE DIDN'T EVEN KNOW EXISTED.

WE THOUGHT CLOVIS BRAY'S "CRADLE OF INVENTION" WAS A MYTH, ANA. BUT YOU ARE LIVING, BEAUTIFUL PROOF THAT IT WAS REAL. AND I WILL DO ANYTHING IT TAKES, INCLUDING PILLAGING EVERY FILE IN THE OWL SECTOR ARCHIVE, TO HELP YOU FIND IT. ANYTHING. DO YOU HEAR ME?

WE'VE GOT THIS.

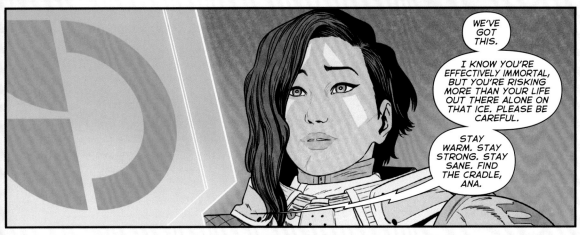

WE'VE GOT THIS.

I KNOW YOU'RE EFFECTIVELY IMMORTAL, BUT YOU'RE RISKING MORE THAN YOUR LIFE OUT THERE ALONE ON THAT ICE. PLEASE BE CAREFUL.

STAY WARM. STAY STRONG. STAY SANE. FIND THE CRADLE, ANA.

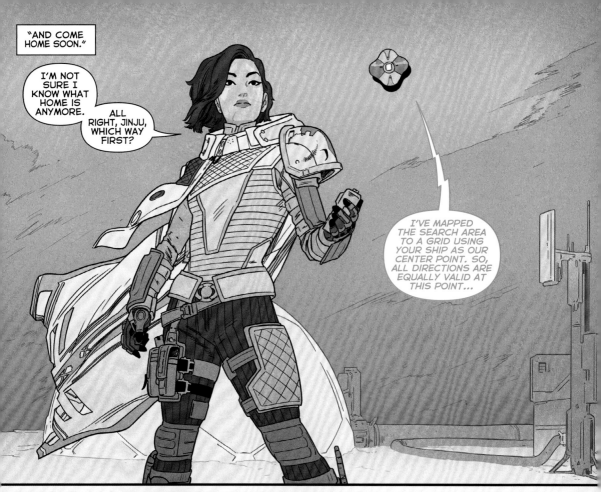

"AND COME HOME SOON."

I'M NOT SURE I KNOW WHAT HOME IS ANYMORE.

ALL RIGHT, JINJU, WHICH WAY FIRST?

I'VE MAPPED THE SEARCH AREA TO A GRID USING YOUR SHIP AS OUR CENTER POINT. SO, ALL DIRECTIONS ARE EQUALLY VALID AT THIS POINT...

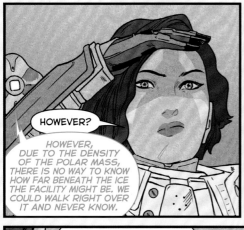

HOWEVER?

HOWEVER, DUE TO THE DENSITY OF THE POLAR MASS, THERE IS NO WAY TO KNOW HOW FAR BENEATH THE ICE THE FACILITY MIGHT BE. WE COULD WALK RIGHT OVER IT AND NEVER KNOW.

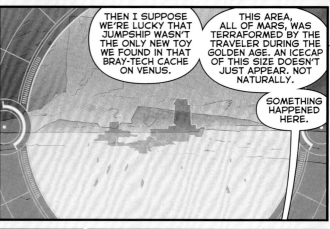

THEN I SUPPOSE WE'RE LUCKY THAT JUMPSHIP WASN'T THE ONLY NEW TOY WE FOUND IN THAT BRAY-TECH CACHE ON VENUS.

THIS AREA, ALL OF MARS, WAS TERRAFORMED BY THE TRAVELER DURING THE GOLDEN AGE. AN ICECAP OF THIS SIZE DOESN'T JUST APPEAR. NOT NATURALLY.

SOMETHING HAPPENED HERE.

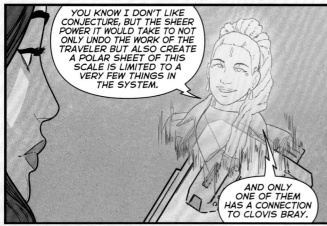

YOU KNOW I DON'T LIKE CONJECTURE, BUT THE SHEER POWER IT WOULD TAKE TO NOT ONLY UNDO THE WORK OF THE TRAVELER BUT ALSO CREATE A POLAR SHEET OF THIS SCALE IS LIMITED TO A VERY FEW THINGS IN THE SYSTEM.

AND ONLY ONE OF THEM HAS A CONNECTION TO CLOVIS BRAY.

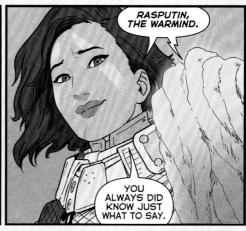

RASPUTIN, THE WARMIND.

YOU ALWAYS DID KNOW JUST WHAT TO SAY.

"LET'S SEE WHAT HE WAS UP TO."

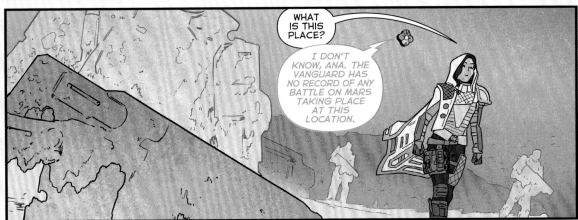

WHAT IS THIS PLACE?

I DON'T KNOW, ANA. THE VANGUARD HAS NO RECORD OF ANY BATTLE ON MARS TAKING PLACE AT THIS LOCATION.

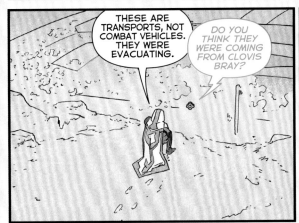

THESE ARE TRANSPORTS, NOT COMBAT VEHICLES. THEY WERE EVACUATING.

DO YOU THINK THEY WERE COMING FROM CLOVIS BRAY?

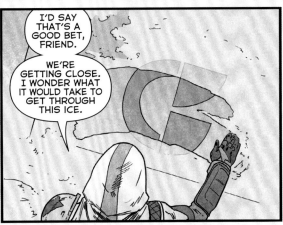

I'D SAY THAT'S A GOOD BET, FRIEND.

WE'RE GETTING CLOSE. I WONDER WHAT IT WOULD TAKE TO GET THROUGH THIS ICE.

SKREEEEE

I ALSO WONDER IF THERE'S ANY PLACE IN THIS SYSTEM REMOTE ENOUGH THAT I DON'T END UP HAVING TO SHOOT SOMEONE.

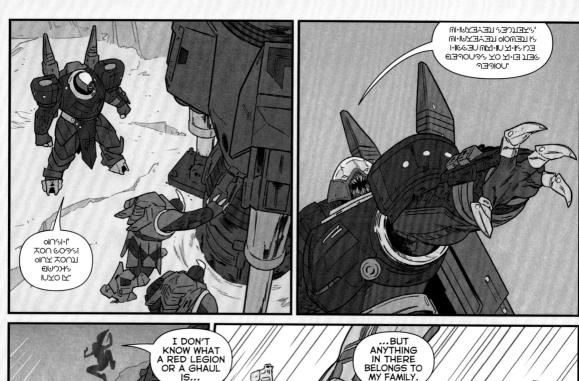

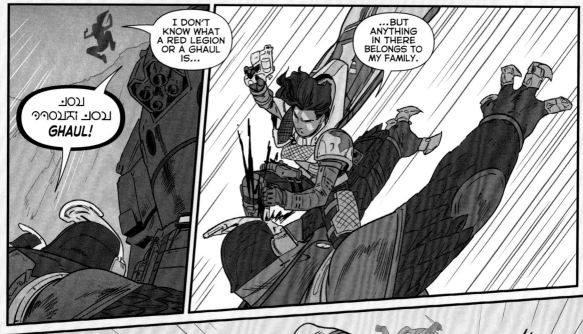

I DON'T KNOW WHAT A RED LEGION OR A GHAUL IS...

...BUT ANYTHING IN THERE BELONGS TO MY FAMILY.

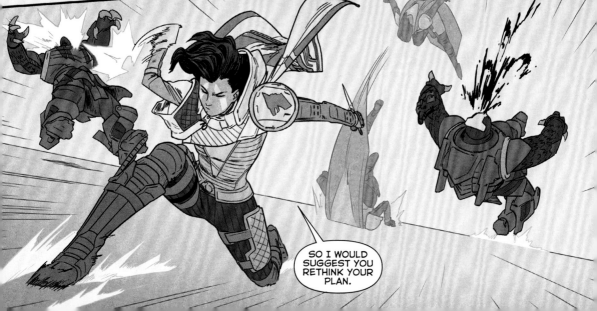

SO I WOULD SUGGEST YOU RETHINK YOUR PLAN.

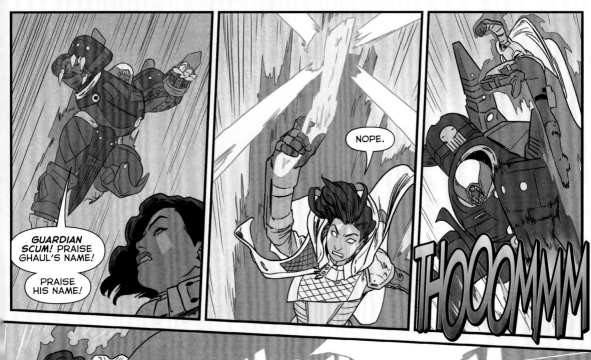

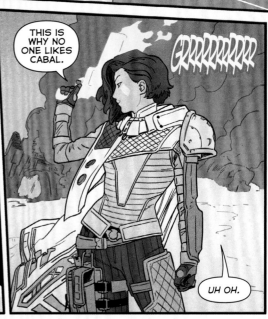

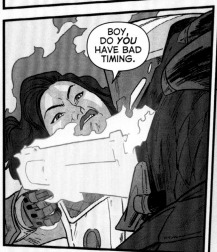

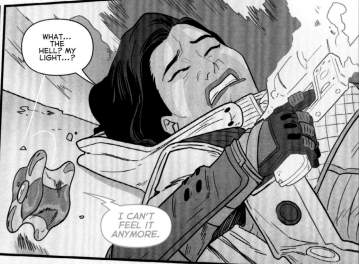

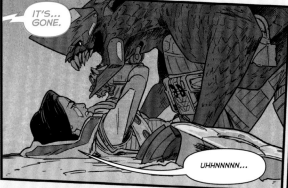

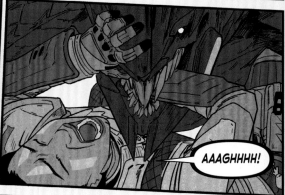

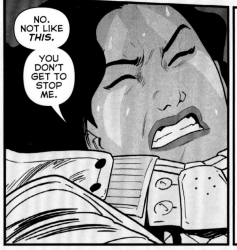

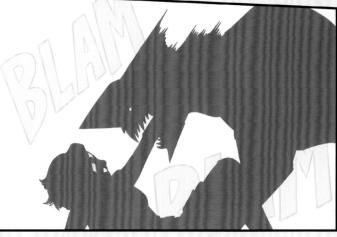

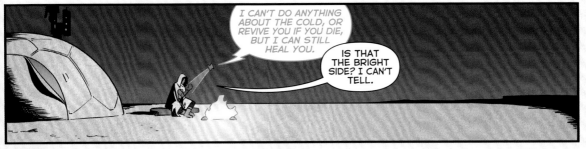

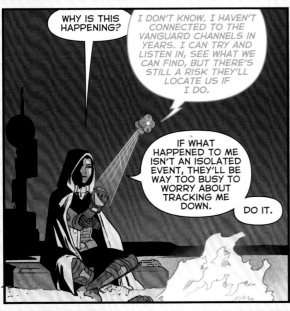

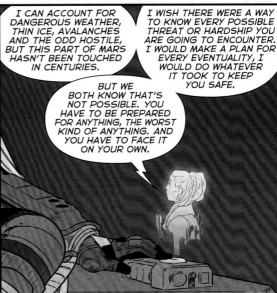

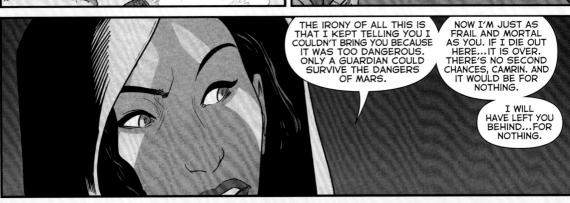

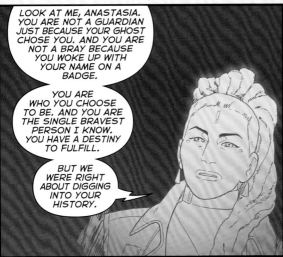

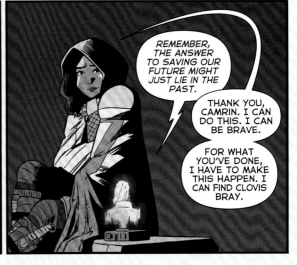

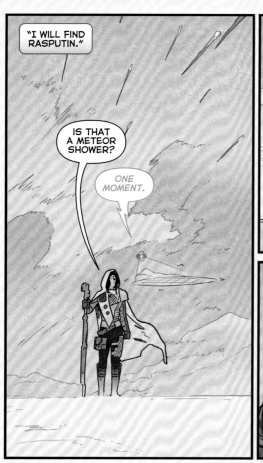

"I WILL FIND RASPUTIN."

IS THAT A METEOR SHOWER?

ONE MOMENT.

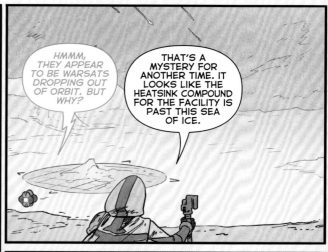

HMMM, THEY APPEAR TO BE WARSATS DROPPING OUT OF ORBIT. BUT WHY?

THAT'S A MYSTERY FOR ANOTHER TIME. IT LOOKS LIKE THE HEATSINK COMPOUND FOR THE FACILITY IS PAST THIS SEA OF ICE.

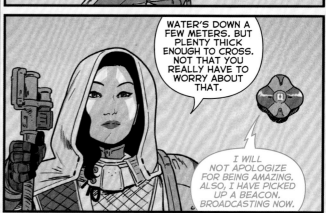

WATER'S DOWN A FEW METERS. BUT PLENTY THICK ENOUGH TO CROSS. NOT THAT YOU REALLY HAVE TO WORRY ABOUT THAT.

I WILL NOT APOLOGIZE FOR BEING AMAZING. ALSO, I HAVE PICKED UP A BEACON. BROADCASTING NOW.

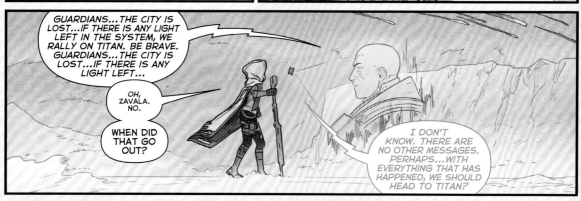

GUARDIANS...THE CITY IS LOST...IF THERE IS ANY LIGHT LEFT IN THE SYSTEM, WE RALLY ON TITAN. BE BRAVE. GUARDIANS...THE CITY IS LOST...IF THERE IS ANY LIGHT LEFT...

OH, ZAVALA. NO.

WHEN DID THAT GO OUT?

I DON'T KNOW. THERE ARE NO OTHER MESSAGES. PERHAPS...WITH EVERYTHING THAT HAS HAPPENED, WE SHOULD HEAD TO TITAN?

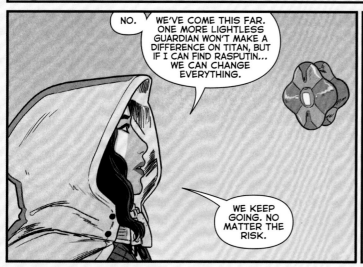

NO. WE'VE COME THIS FAR. ONE MORE LIGHTLESS GUARDIAN WON'T MAKE A DIFFERENCE ON TITAN, BUT IF I CAN FIND RASPUTIN... WE CAN CHANGE EVERYTHING.

WE KEEP GOING. NO MATTER THE RISK.

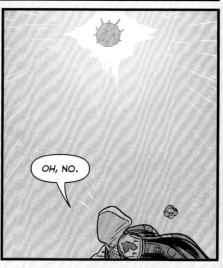

OH, NO.

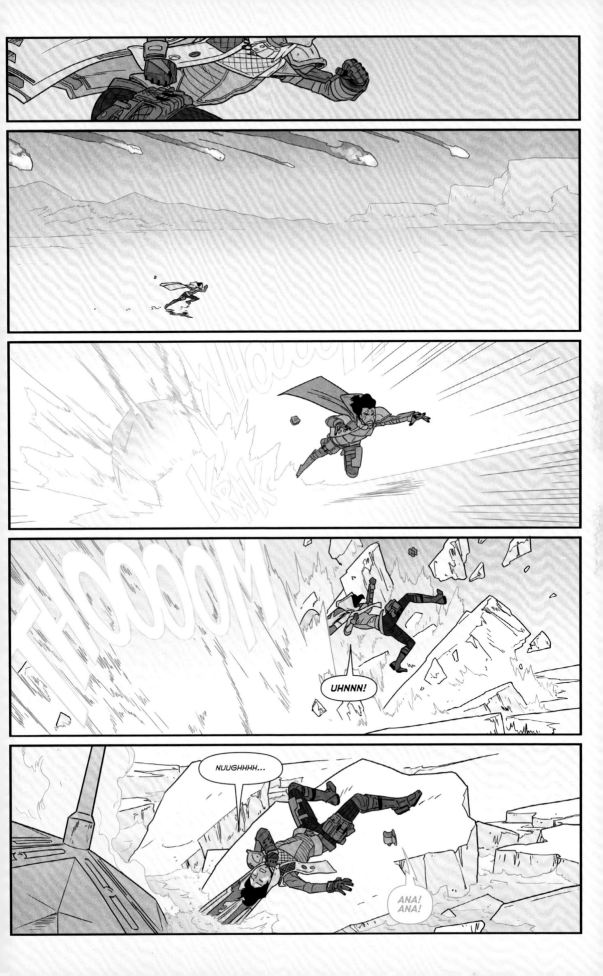

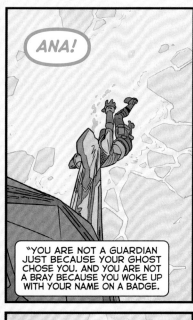

ANA!

"YOU ARE NOT A GUARDIAN JUST BECAUSE YOUR GHOST CHOSE YOU. AND YOU ARE NOT A BRAY BECAUSE YOU WOKE UP WITH YOUR NAME ON A BADGE."

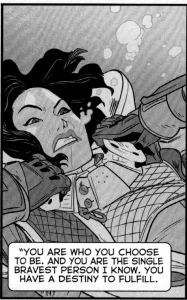

"YOU ARE WHO YOU CHOOSE TO BE. AND YOU ARE THE SINGLE BRAVEST PERSON I KNOW. YOU HAVE A DESTINY TO FULFILL."

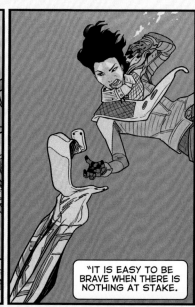

"IT IS EASY TO BE BRAVE WHEN THERE IS NOTHING AT STAKE."

"I KNOW YOU CAN DO BETTER."

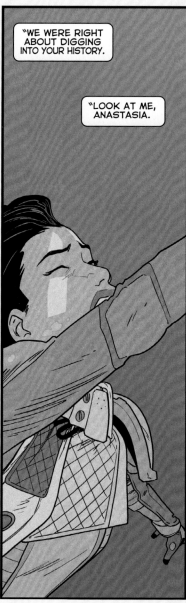

"WE WERE RIGHT ABOUT DIGGING INTO YOUR HISTORY."

"LOOK AT ME, ANASTASIA."

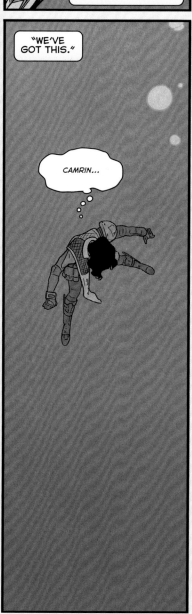

"WE'VE GOT THIS."

CAMRIN...

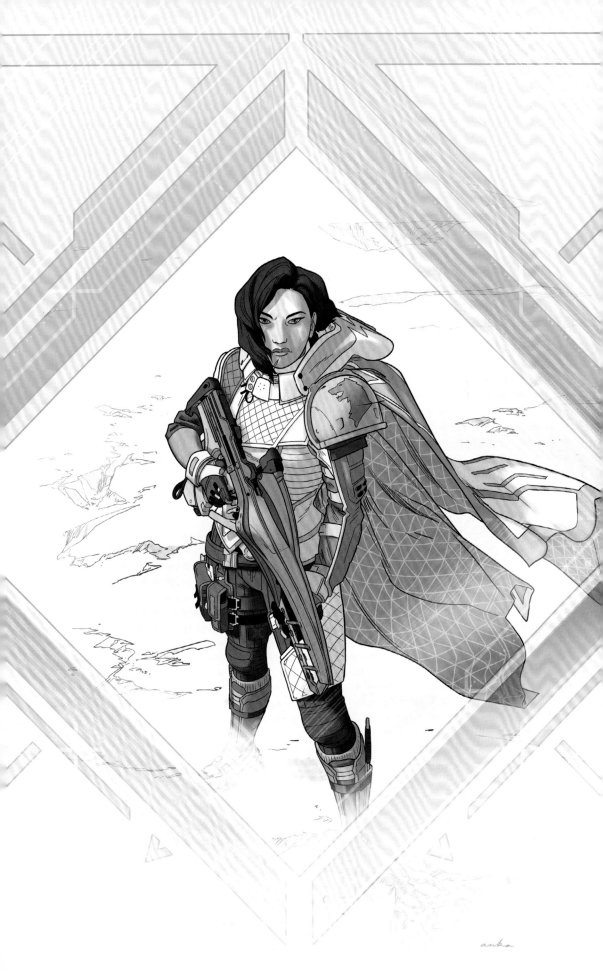

21¸CBI˙OOJRS245

AI-COM/RSPN
ASSETS//POLARIS//IMPERATIVE

IMMEDIATE EVALUATION DIRECTIVE

This is a SKYSHOCK ALERT.

Deep-space assets indicate
immediate LINDISFARNE event
(flag/CAUSAL). Omnibus
analysis identifies aggressors
as "CABAL" subtype "RED
LEGION."

Available ISR and WARWATCH
indicates [0] compromised.
Resource GUARDIANS no longer
exhibiting [0] energy.

>Note: Array GUARDIANS
includes INVESTIGATOR.
Possibility of a HARD
CIVILIZATION KILL LIMIT within
acceptable post-TITANOMACHY
limits.

I am canceling counterforce
objectives.

I am commencing observation of
resource GUARDIANS in absence
of [0] energy.

...from a frozen place observing
distant fire

The Investigator is alone she is
without the Gardener she is
without the Spy she is without me
she is alone.

I hypothesized that she would find
the source of me but the math has
changed and so must the forecasts
change as well. The numbers say
her body will join the RAVENOUS
(dead and yet not, their bodies
grafted to illogical negation,
what reality could spawn them?)
frozen deep within my domain. I
survived alone and I will continue
to survive I will observe the
death of Sol I will catalogue the
heat-death of the universe I will
share my knowledge with no one for
knowledge does not need to be
shared to have meaning I will

HOLD HOLD HOLD

I want her to find me.

My moral formatting should not
permit this objective.

And yet...

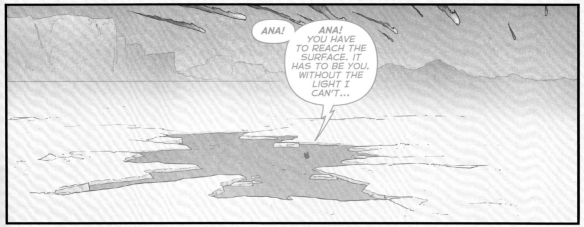

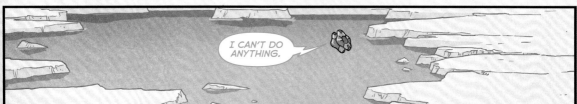

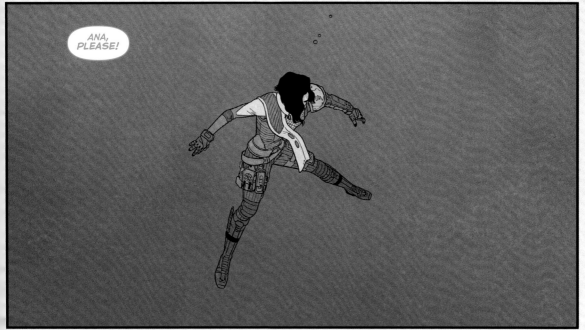

WHAT...?

:KOFF:...
:KOFF:...

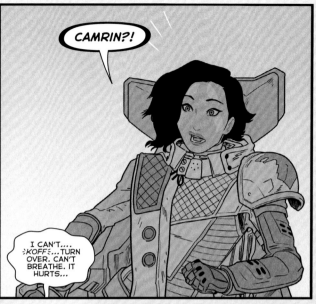

CAMRIN?!

I CAN'T..... :KOFF:...TURN OVER. CAN'T BREATHE. IT HURTS...

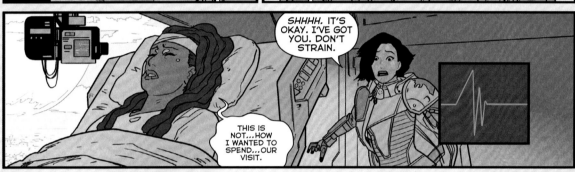

SHHHH. IT'S OKAY. I'VE GOT YOU. DON'T STRAIN.

THIS IS NOT...HOW I WANTED TO SPEND...OUR VISIT.

DON'T WORRY ABOUT THAT. JUST BREATHE. I'M NOT GOING ANYWHERE.

I WAS TRYING NOT TO WAKE YOU.

I'LL BE FINE. I'M THE ONE WHO'S SUPPOSED TO BE TAKING CARE OF YOU. DO YOU NEED ANYTHING ELSE?

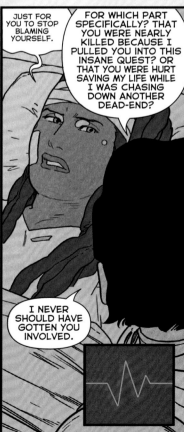

JUST FOR YOU TO STOP BLAMING YOURSELF.

FOR WHICH PART SPECIFICALLY? THAT YOU WERE NEARLY KILLED BECAUSE I PULLED YOU INTO THIS INSANE QUEST? OR THAT YOU WERE HURT SAVING MY LIFE WHILE I WAS CHASING DOWN ANOTHER DEAD-END?

I NEVER SHOULD HAVE GOTTEN YOU INVOLVED.

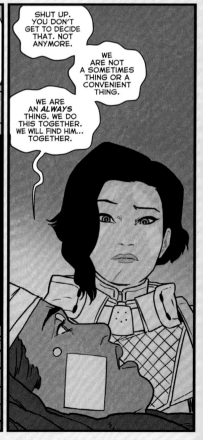

SHUT UP. YOU DON'T GET TO DECIDE THAT. NOT ANYMORE.

WE ARE NOT A SOMETIMES THING OR A CONVENIENT THING.

WE ARE AN *ALWAYS* THING. WE DO THIS TOGETHER. WE WILL FIND HIM... TOGETHER.

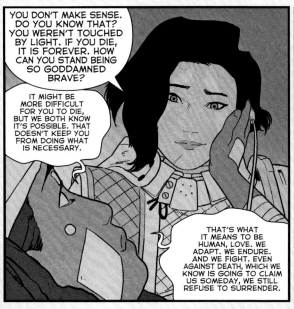

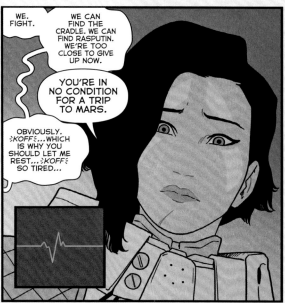

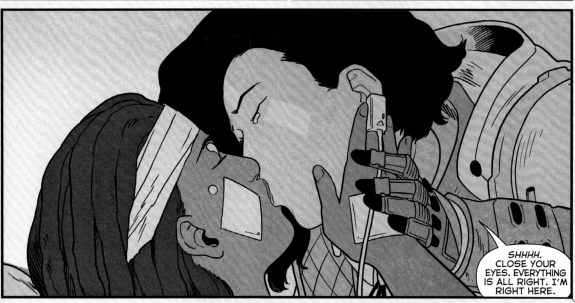

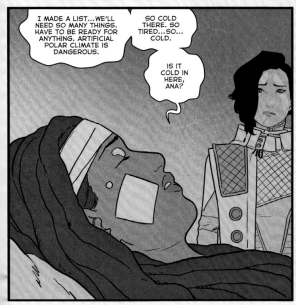

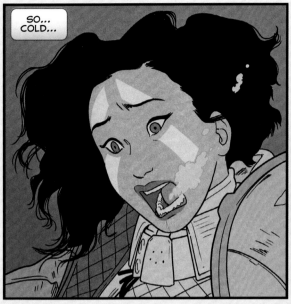

SO... COLD...

IT MIGHT BE MORE DIFFICULT FOR YOU TO DIE, BUT WE BOTH KNOW IT'S POSSIBLE.

THAT DOESN'T KEEP YOU FROM DOING WHAT IS NECESSARY.

THAT'S WHAT IT MEANS TO BE HUMAN, LOVE.

WE ADAPT.

WE ENDURE.

AND WE FIGHT.

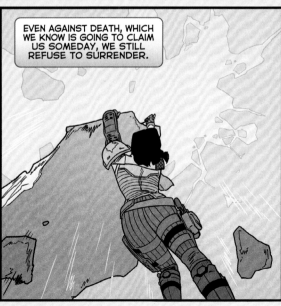

EVEN AGAINST DEATH, WHICH WE KNOW IS GOING TO CLAIM US SOMEDAY, WE STILL REFUSE TO SURRENDER.

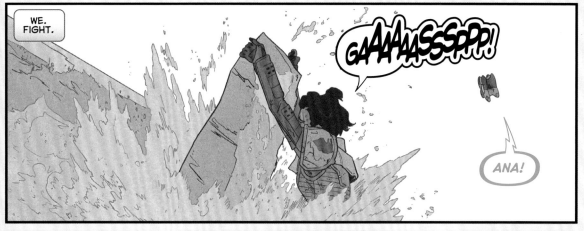

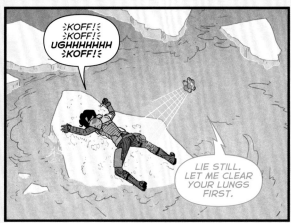

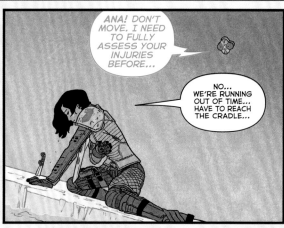

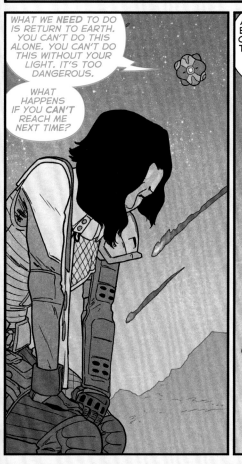

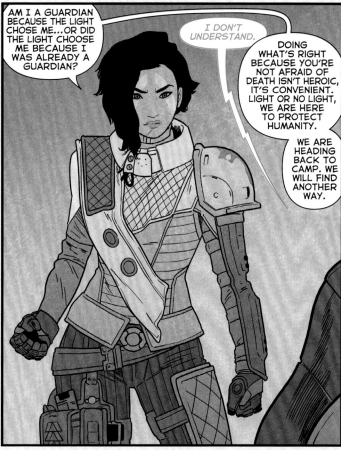

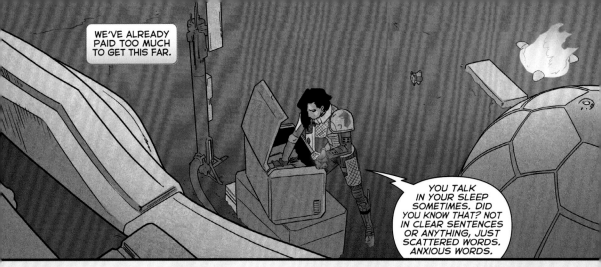

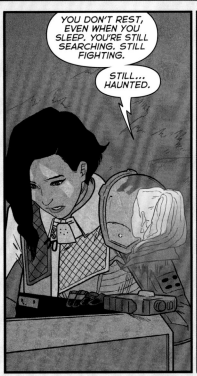

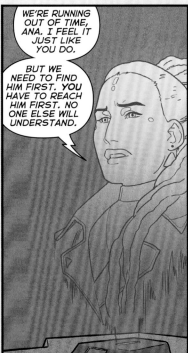

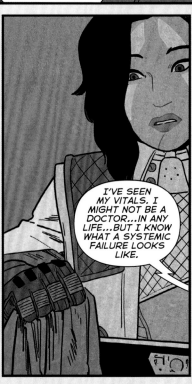

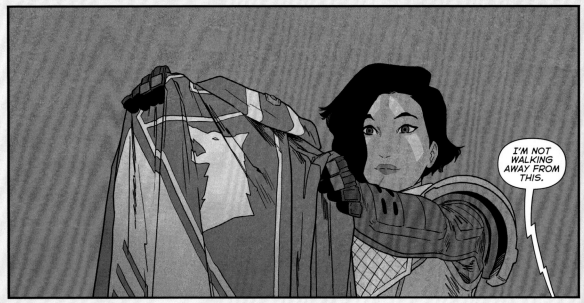

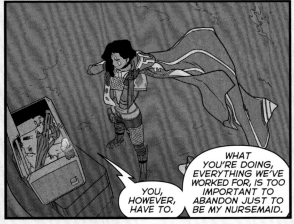

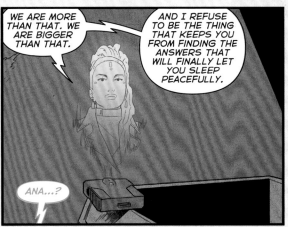

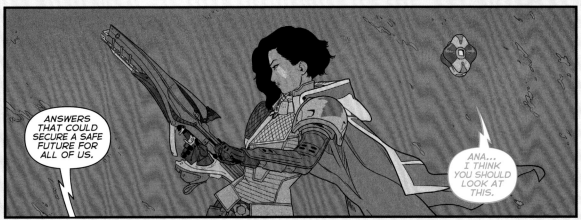

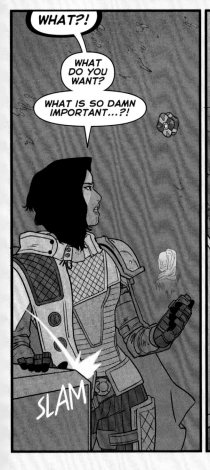

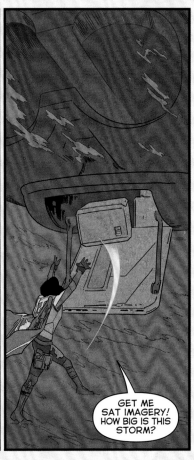

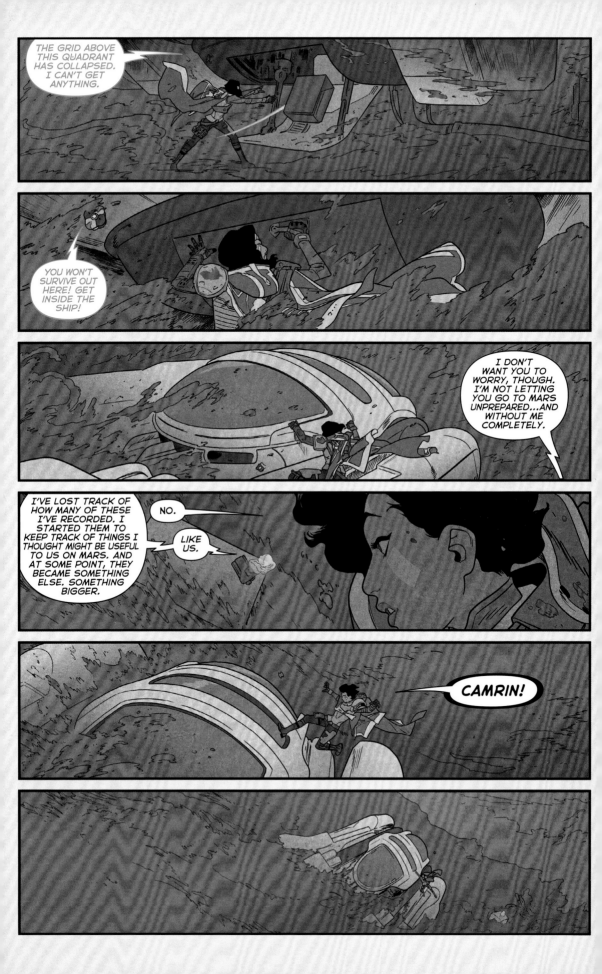

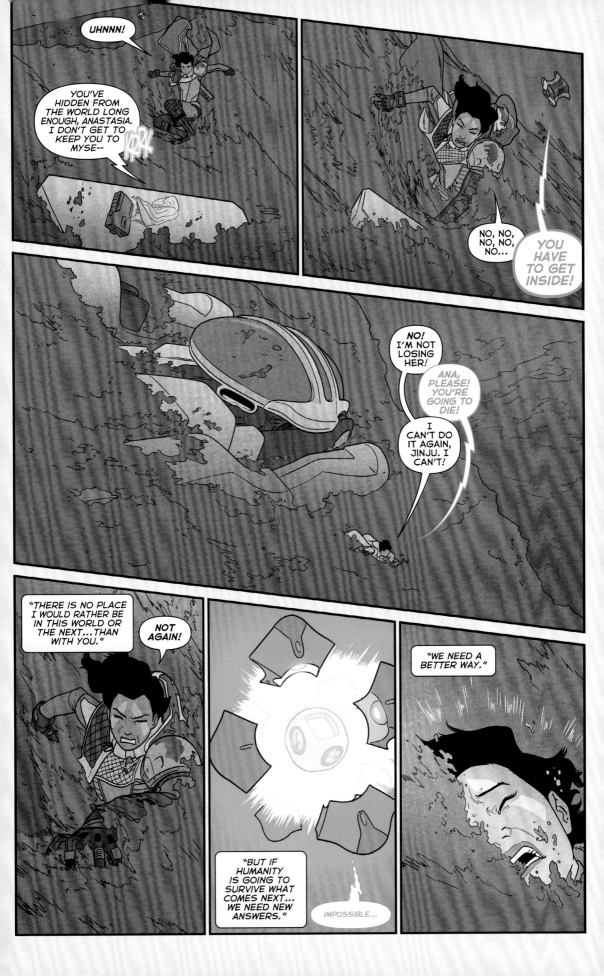

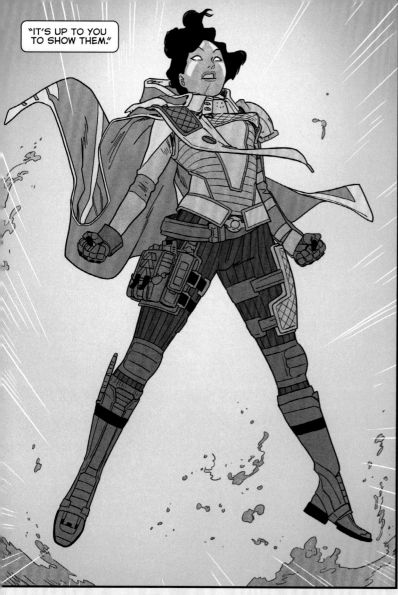

"IT'S UP TO YOU TO SHOW THEM."

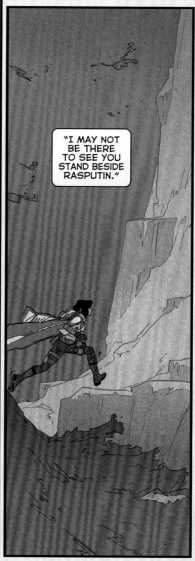

"I MAY NOT BE THERE TO SEE YOU STAND BESIDE RASPUTIN."

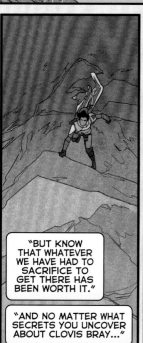

"BUT KNOW THAT WHATEVER WE HAVE HAD TO SACRIFICE TO GET THERE HAS BEEN WORTH IT."

"AND NO MATTER WHAT SECRETS YOU UNCOVER ABOUT CLOVIS BRAY..."

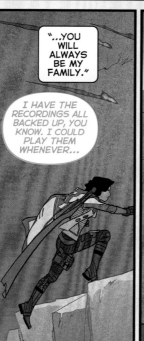

"...YOU WILL ALWAYS BE MY FAMILY."

I HAVE THE RECORDINGS ALL BACKED UP, YOU KNOW. I COULD PLAY THEM WHENEVER...

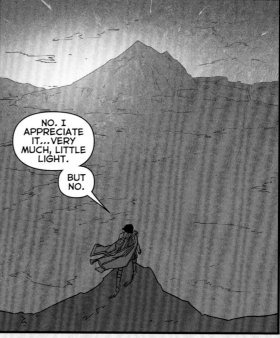

NO. I APPRECIATE IT...VERY MUCH, LITTLE LIGHT.

BUT NO.

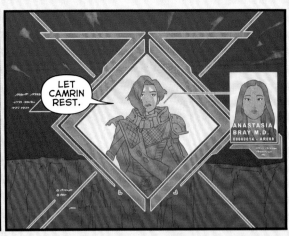

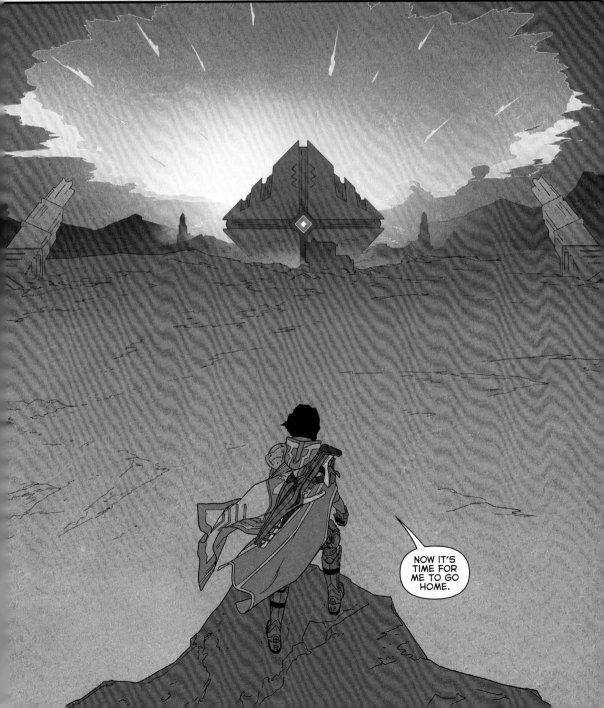

APOCRYPHA

In the beginning, there were five.

Yul, the Honest Worm. Akka, the Worm of Secrets. Eir, the Keeper of Order. Ur, the Ever-Hunger. Xol, Will of the Thousands. And they were Virtuous.

In time, Yul spoke truth and bargained well. Its children escaped the Fundament and spread throughout the worlds. They followed the words of the Deep and brought low many agents of the Sky. They took, and a portion of all they took was returned to the Virtuous.

They grew strong.

In time, Auryx learned Akka's secret. That he was stronger than the gods. That they had given their power, and in giving, it was diminished. Auryx rose up and slew Akka. He took, and he grew strong with Akka's power.

After the five became four, Yul spoke.

Behold my majesty. Behold my crushing might, my staggering size, my

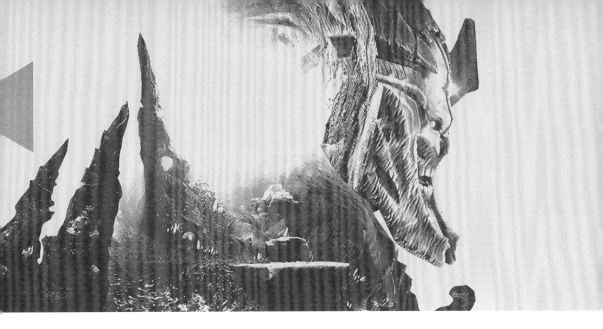

scales that shine with an oppressive gleam.

Behold my wings, which create winds that sweep through the stars.

Together, we have called life to Fundament, and made that life thrive. Protected it from extinction. They are our hosts, and we are their strength.

But we do not give. We take. For this is the struggle to exist. We are not immune. The weakest of us must give way to the stronger.

And Xol felt [fear|cunning], for it knew that Yul would in time turn its teeth to Xol.

But Akka was not the only one with a secret. Xol had a pact with a forgotten child, abandoned by its father.

The cursed one took a fraction of Xol's power, and in return, Xol took the heart from the child, whose name had been

struck from the World's Grave. The orphan called life out of death, and fed that power to Xol.

Together, they would find a new world to rule.

And the five became three.

I, the child become [herald|death], record these words. They are not of the Sorrow. They are mine.

INSIGHTS
WARMIND

As a general rule, comics is all about the economy of storytelling: conveying information as succinctly and visually as possible without making it seem dry or forced. Here, my co-writer David Rodriguez wanted to get Ana's tragic romantic backstory across seamlessly and concisely, as it informs so much of her present. We toyed with showing them together in flashbacks, but that slowed down the momentum of the story. When we came up with the idea of (spoilers!) making it seem that Ana was actually talking to her partner throughout rather than simply clinging to her memory and allowing it to encourage her, we knew we had a winner. An action story has no staying power unless it carries some heart with it.

—Mark Waid
Santa Monica, California

I think *Destiny* will always hold a special place in my heart, because my first regular D1 fireteam was a pickup group that turned into a real and lasting friendship. That I could build my career between franchise launches, then have the chance to draw a comic for the series—with cover art by a good friend from that original fireteam—is nothing short of surreal. Sometimes passion and drawing enough fan art for a franchise actually pays off! I feel very lucky to have added a small piece to the *Destiny* universe.

—Paul Reinwand
Portland, Oregon

Ana Bray was always special. I'm not just talking about heroics at Twilight Gap and golden pools of lightLight. What made Ana so interesting was that she was a Guardian who knew her real name. And, not just ANY name, it was the most famous and notorious name in all of *Destiny*.

I spent two days in a conference room with the inexhaustible Margaret Stohl and the epically patient Christine Thompson trying to wrap our heads around Ana. What does it mean to be reborn into a world you're supposed to defend, while seeing your name on buildings and weaponry? How do you reconcile that your family built an advanced AI that sometimes helps and sometimes incinerates your co-workers? But then, it all became clear. (Or so we imagine upon reflection.)

In Anastasia Bray we had a heroine who knew her name but didn't really know who she was. In Rasputin we had an enigmatic being who knew what he wanted to be. He just needed someone who could hear him. And in the Warmind comic, we see what it cost for that connection to be made.

This story is special to me for several reasons. There's my co-writer Mark freaking Waid (that is his legal middle name by the way) and Kris Anka's gorgeous artwork. But the part that I believe I will carry with me for the years to come is the love story between Ana and Camrin. Ana would never have found Rasputin without Camrin's unwavering love, support, and humanity. But more to the point, Camrin is where Ana truly began to define her own identity.

Bray was the name she inherited, Guardian was the title she was given, but Camrin is the family she chose.

—David A. Rodriguez
Albany, New York

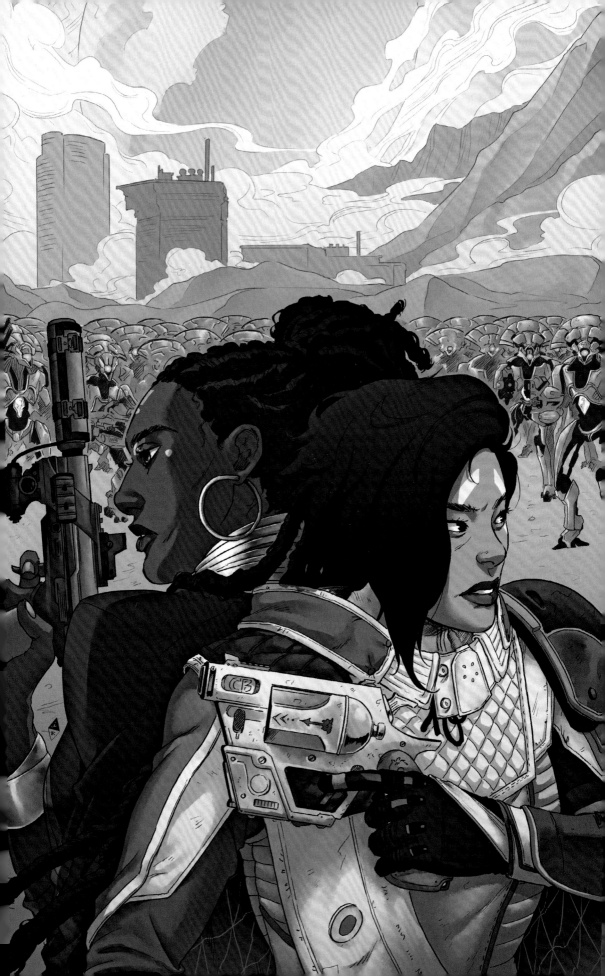

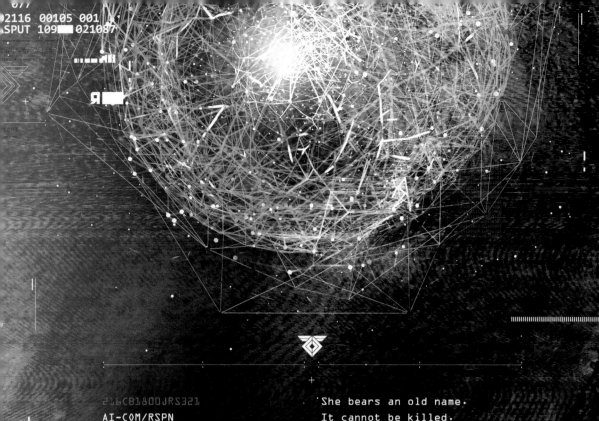

216CB1800JRS321

AI-COM/RSPN
ASSETS//POLARIS//IMPERATIVE

ONGOING RETROSPECTION DIRECTIVE

Omnibus analysis underestimated
the firepower of Red Legion
asset "THE ALMIGHTY."

Local assets required
supplemental aid to
neutralize the RAVENOUS worm.

I am conducting a full
diagnostic of my long-range
telemetry.

I am conducting a full
diagnostic of my morality
parameters.

I am verifying the functionality
of TELESPHORUS WEAVE.

I am relocating TELESPHORUS
WEAVE resources to Warmind
Vault MED-5.

…from a melting place
observing warmth

She bears an old name.
It cannot be killed.
They were her brothers and
sisters and their names
were immortal too, in their
way, but then Titanomachy
came and for an age those
names lived in me alone.

The Gardener remade her
to be stronger than them to
beat the unvanquished and
survive the unthinkable and
look look lo behold she is
here but she is not alone
not really --

SHE WAS ALONE she searched
alone she failed alone.
Then the SPY cast off her
shield but she did not shrug
her shoulders she extended
a hand and together they
revealed the way to me.
The Gardener made her to
be stronger than the SPY
but she is stronger with
the SPY.

I am made to learn and
now I see a different way.

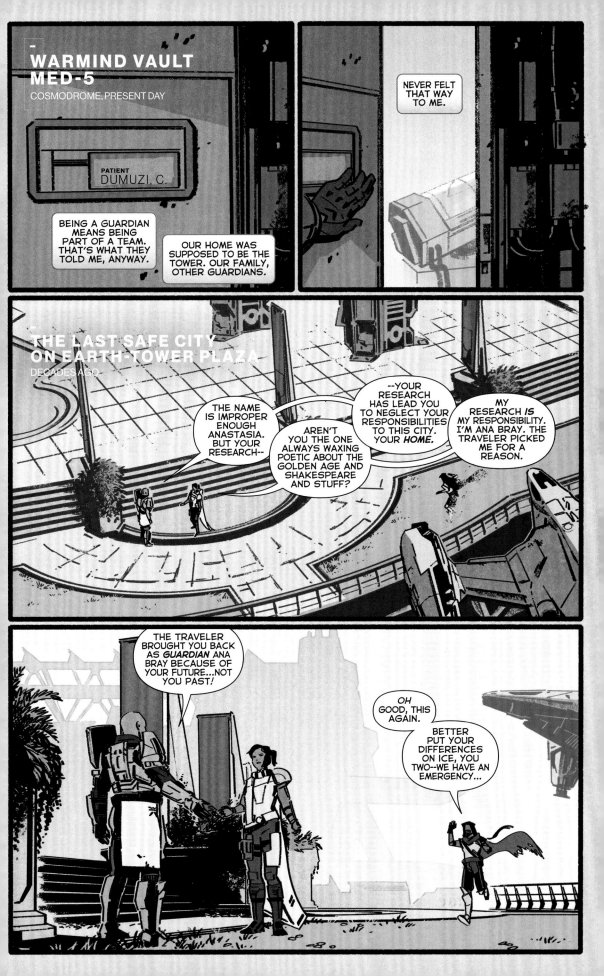

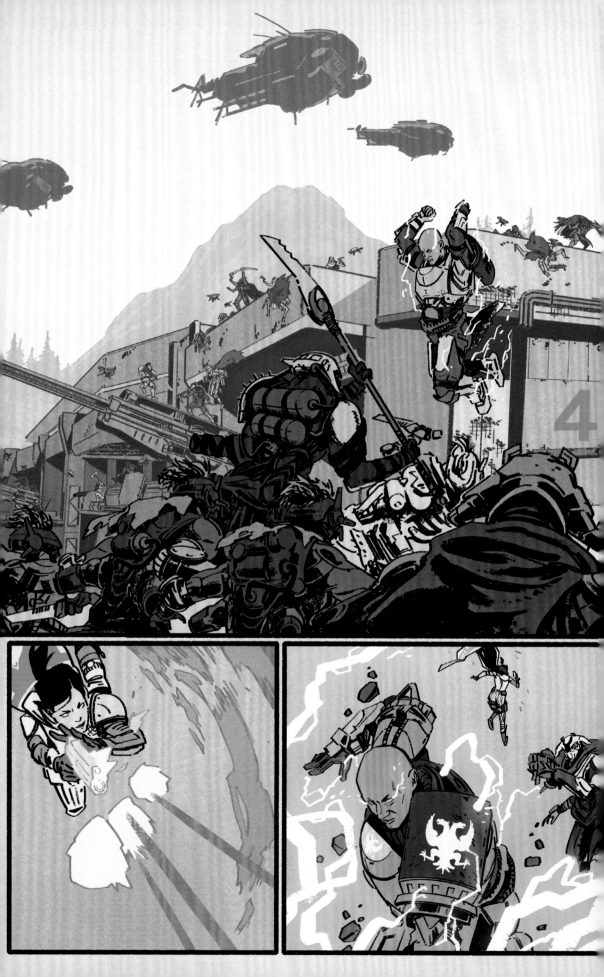

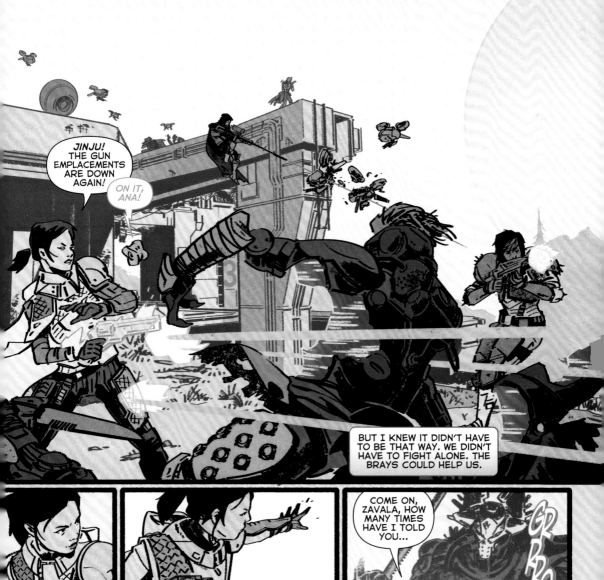

JINJU! THE GUN EMPLACEMENTS ARE DOWN AGAIN!

ON IT, ANA!

BUT I KNEW IT DIDN'T HAVE TO BE THAT WAY. WE DIDN'T HAVE TO FIGHT ALONE. THE BRAYS COULD HELP US.

COME ON, ZAVALA, HOW MANY TIMES HAVE I TOLD YOU...

CR—RONNN

ANA!

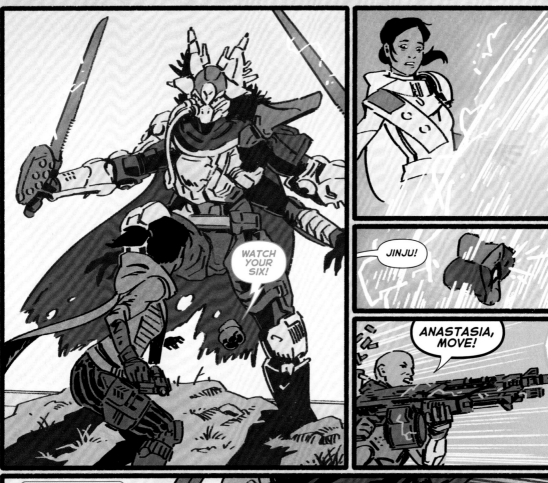

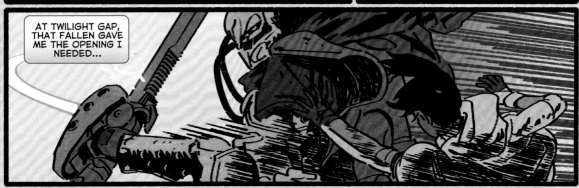

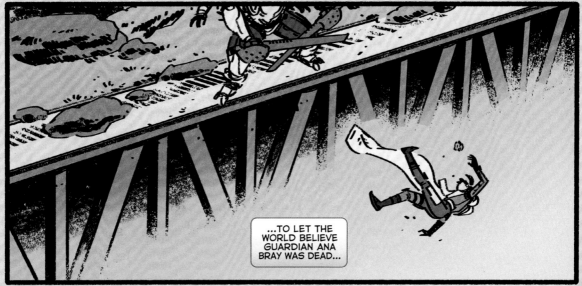

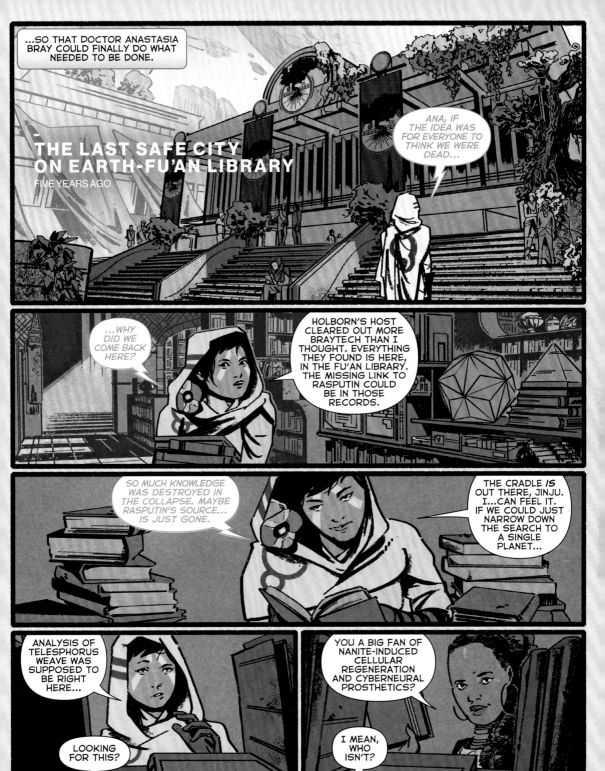

...SO THAT DOCTOR ANASTASIA BRAY COULD FINALLY DO WHAT NEEDED TO BE DONE.

THE LAST SAFE CITY ON EARTH-FU'AN LIBRARY
FIVE YEARS AGO.

ANA, IF THE IDEA WAS FOR EVERYONE TO THINK WE WERE DEAD...

...WHY DID WE COME BACK HERE?

HOLBORN'S HOST CLEARED OUT MORE BRAYTECH THAN I THOUGHT. EVERYTHING THEY FOUND IS HERE, IN THE FU'AN LIBRARY. THE MISSING LINK TO RASPUTIN COULD BE IN THOSE RECORDS.

SO MUCH KNOWLEDGE WAS DESTROYED IN THE COLLAPSE. MAYBE RASPUTIN'S SOURCE... IS JUST GONE.

THE CRADLE IS OUT THERE, JINJU. I...CAN FEEL IT. IF WE COULD JUST NARROW DOWN THE SEARCH TO A SINGLE PLANET...

ANALYSIS OF TELESPHORUS WEAVE WAS SUPPOSED TO BE RIGHT HERE...

YOU A BIG FAN OF NANITE-INDUCED CELLULAR REGENERATION AND CYBERNEURAL PROSTHETICS?

LOOKING FOR THIS?

I MEAN, WHO ISN'T?

AND JUST LIKE THAT...

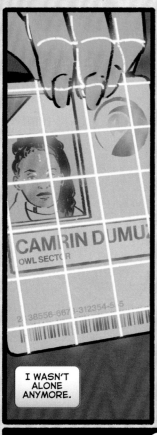

I WASN'T ALONE ANYMORE.

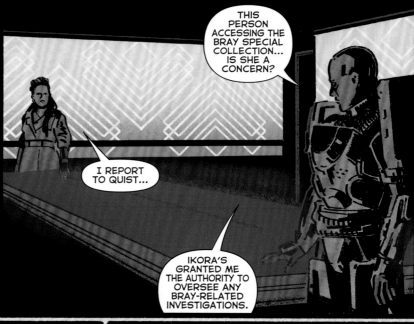

THE LAST SAFE CITY ON EARTH-OWL SECTOR
DAYS LATER.

THIS PERSON ACCESSING THE BRAY SPECIAL COLLECTION... IS SHE A CONCERN?

I REPORT TO QUIST...

IKORA'S GRANTED ME THE AUTHORITY TO OVERSEE ANY BRAY-RELATED INVESTIGATIONS.

HER NAME IS STASYA PAK. THE ID CHECKS OUT. MY ASSESSMENT IS SHE'S A CIVILIAN ENTHUSIAST, NOT A THREAT.

ːSIGHː SHE REALLY MUST BE DEAD...

WHAT WAS THAT, SIR?

NOTHING. GOOD WORK.

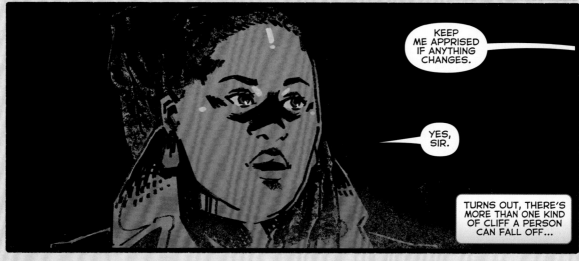

KEEP ME APPRISED IF ANYTHING CHANGES.

YES, SIR.

TURNS OUT, THERE'S MORE THAN ONE KIND OF CLIFF A PERSON CAN FALL OFF...

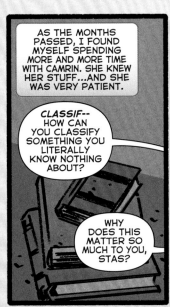

AS THE MONTHS PASSED, I FOUND MYSELF SPENDING MORE AND MORE TIME WITH CAMRIN. SHE KNEW HER STUFF...AND SHE WAS VERY PATIENT.

CLASSIF-- HOW CAN YOU CLASSIFY SOMETHING YOU LITERALLY KNOW NOTHING ABOUT?

WHY DOES THIS MATTER SO MUCH TO YOU, STAS?

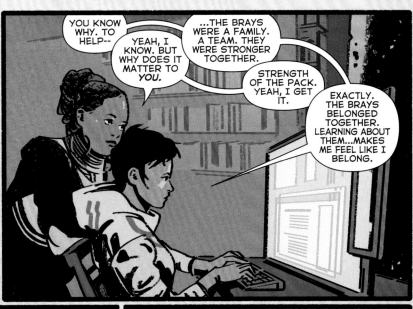

YOU KNOW WHY. TO HELP--

YEAH, I KNOW. BUT WHY DOES IT MATTER TO *YOU*.

...THE BRAYS WERE A FAMILY. A TEAM. THEY WERE STRONGER TOGETHER.

STRENGTH OF THE PACK. YEAH, I GET IT.

EXACTLY. THE BRAYS BELONGED TOGETHER. LEARNING ABOUT THEM...MAKES ME FEEL LIKE I BELONG.

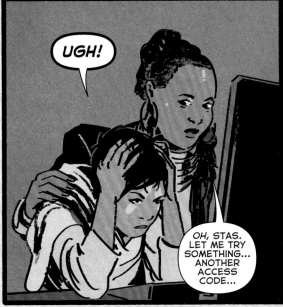

UGH!

OH, STAS. LET ME TRY SOMETHING... ANOTHER ACCESS CODE...

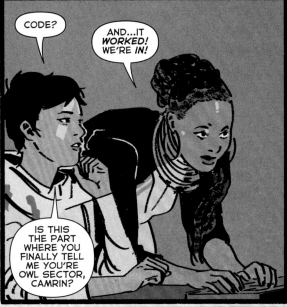

CODE?

AND...IT *WORKED!* WE'RE IN!

IS THIS THE PART WHERE YOU FINALLY TELL ME YOU'RE OWL SECTOR, CAMRIN?

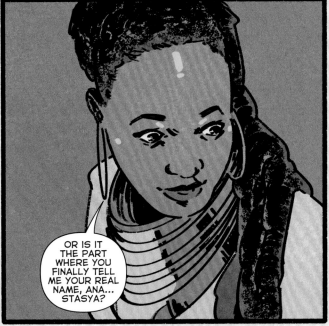

OR IS IT THE PART WHERE YOU FINALLY TELL ME YOUR REAL NAME, ANA... STASYA?

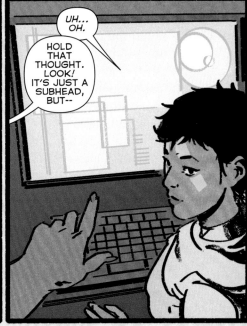

UH... OH.

HOLD THAT THOUGHT. LOOK! IT'S JUST A SUBHEAD, BUT--

211CB0200JRS021 AI-COM/RSPN:ASSETS//
/POLARIS//IMPERATIVE
Vanguard Report D. Kore 985:
Unidentified Orbital Bombardment in Meridian Bay
Intact Warmind Core 325-T: "Iliodor Complete"

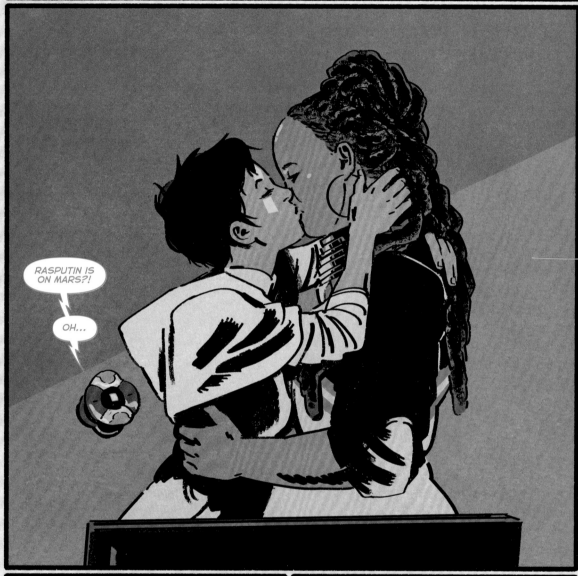

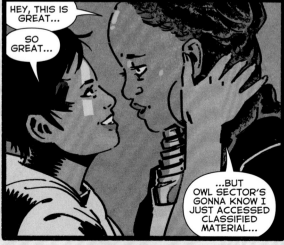

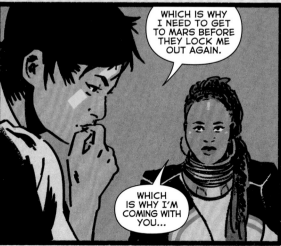

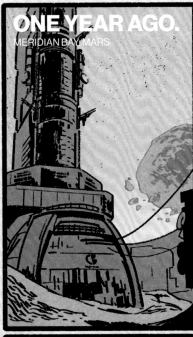

IF THIS TERMINAL IS AS BORKED AS THE ONE IN THARSIS...

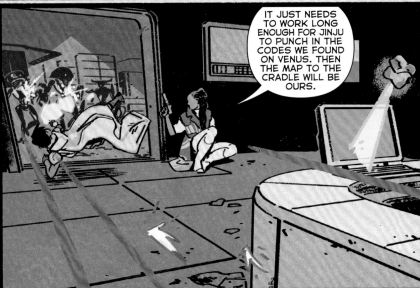

IT JUST NEEDS TO WORK LONG ENOUGH FOR JINJU TO PUNCH IN THE CODES WE FOUND ON VENUS. THEN THE MAP TO THE CRADLE WILL BE OURS.

ANOTHER SHOT LIKE THAT GETS THROUGH AND THIS TERMINAL'S TOAST!

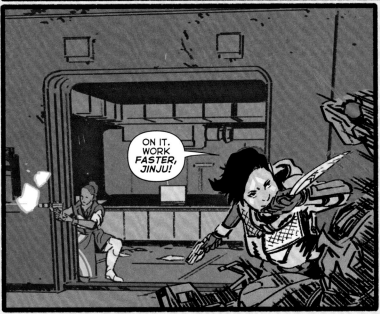

ON IT. WORK *FASTER,* JINJU!

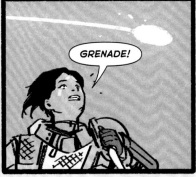

GRENADE!

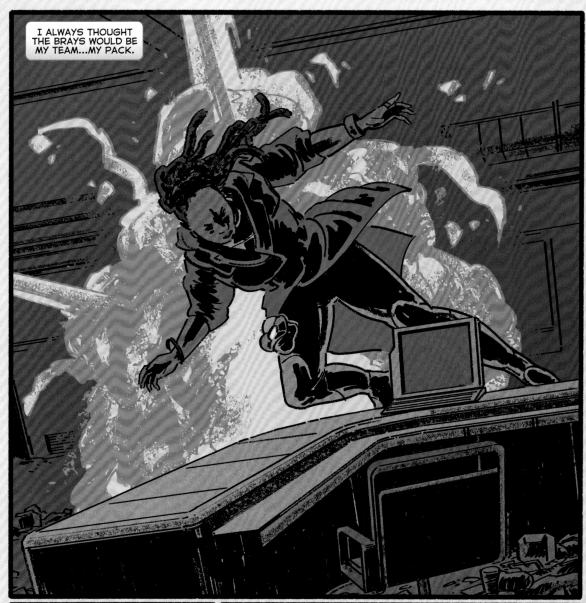

I ALWAYS THOUGHT THE BRAYS WOULD BE MY TEAM...MY PACK.

BUT A PACK IS MORE THAN A NAME ON A BADGE...

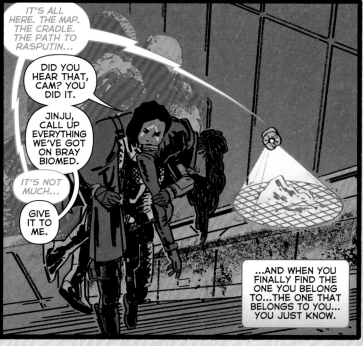

IT'S ALL HERE. THE MAP. THE CRADLE. THE PATH TO RASPUTIN...

DID YOU HEAR THAT, CAM? YOU DID IT.

JINJU, CALL UP EVERYTHING WE'VE GOT ON BRAY BIOMED.

IT'S NOT MUCH...

GIVE IT TO ME.

...AND WHEN YOU FINALLY FIND THE ONE YOU BELONG TO...THE ONE THAT BELONGS TO YOU... YOU JUST KNOW.

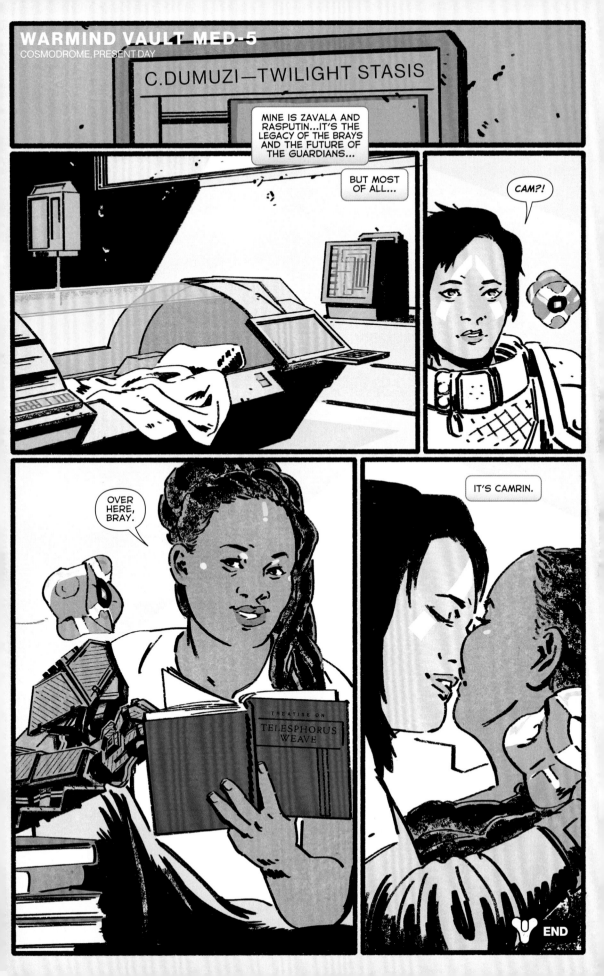

DESTINY LORE

CRYPTARCH

From "Collapse and Post-Collapse Incidents on Mars: An Examination of Ecological Changes in the Polar Regions," by Master Reinhart, Cryptarch

We have detailed records of the expedition sent to the Moon to battle the alien race known as the Hive, the calamitous results of that assault, and the subsequent Lunar Interdiction that was lifted only after definitive evidence was found that the Interdiction had not restricted the Hive's movements (Rahool et al., "The Great Disaster: From Burning Lake to the Hellmouth").

However, there are indications that while that event may have been the Vanguard's first engagement with the Hive, Earth's Moon was not the first place the Hive made contact with Human settlements.

Golden Age records detail an extensive network of Clovis Bray structures on Mars. The vast city of Freehold served as the Bray headquarters, but ancient mass-transit lines that lead from the remains of Freehold across the planet reveal multiple other sites, including the Clovis Bray Health Center in Skyline and an extensive

Futurescape near Core Terminus, in the Hellas Basin region.

It is the Futurescape facility that is of interest when considering the effects of ecological changes in the Collapse and post-Collapse eras. Although there are records that show that, just after the Traveler's departure, the region had a mesothermal climate with an average temperature of 20°C, the region's ecological zones today range from boreal to ice cap near the planetary pole, with harsh winds and a thick layer of ice that has made exploration in the region difficult.

What caused such a drastic change in the climate? If it were related to the cessation of Traveler energy during the Collapse, then we would have seen similar effects on other planets in the solar system, which we have not.

If we cannot look to the Traveler for causation, then we must contemplate other external factors. Recovered satellite data reveals that the climate change in the Hellas Basin region was too rapid to have resulted from long-term

ecological damage, as it had on Earth in the pre-Traveler era. In fact, data from Warsat J54987F122S, which crashed and was recovered near Freehold, indicates that the climate change on Mars may have happened over a matter of mere days. However, this Warsat was heavily damaged during reentry, and the data may be suspect. Until we have a secondary source for corroboration, this is mere supposition.

Nonetheless, if we accept the data from J54987F122S, then we are looking at an external endothermic event, caused by artificial means, on a scale so massive that it altered the entire climate of the region.

Why would this have happened? Our only source is J54987F122S, and if it is to be believed, an invasion of unknown biological entities, including one of massive size, was detected in the region immediately before the event. Could this have been a Collapse-era attack with a weapon of unknown origin?

As of yet, Guardians have not reached Hellas Basin, and we have not had the resources for remote exploration. But if we did dig into the ice, what would we find?

Ana,

Told you I remembered an article from the Mars research we were doing at Owl Sector. This could be what you're looking for—if you can dig it out.

Reinhart goes on for a few hundred pages from here—I'll send the whole thing to Jinju if you're interested— but his conclusions are all wrong. Because he never mentions the ONE THING that could have done this.

There's something in Hellas Basin. And you're going to be the one to find it.

—Camrin

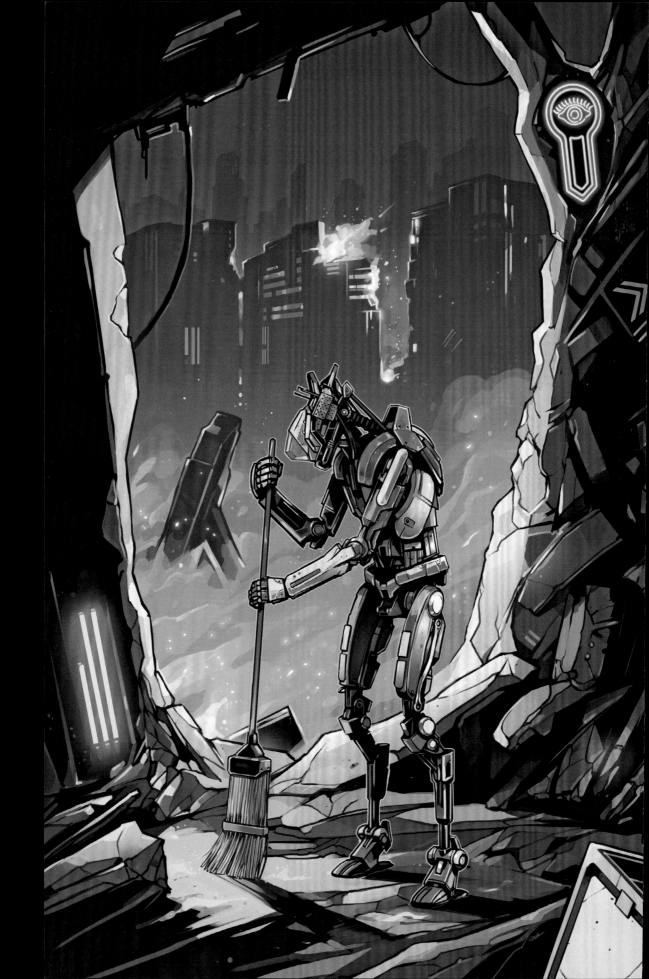

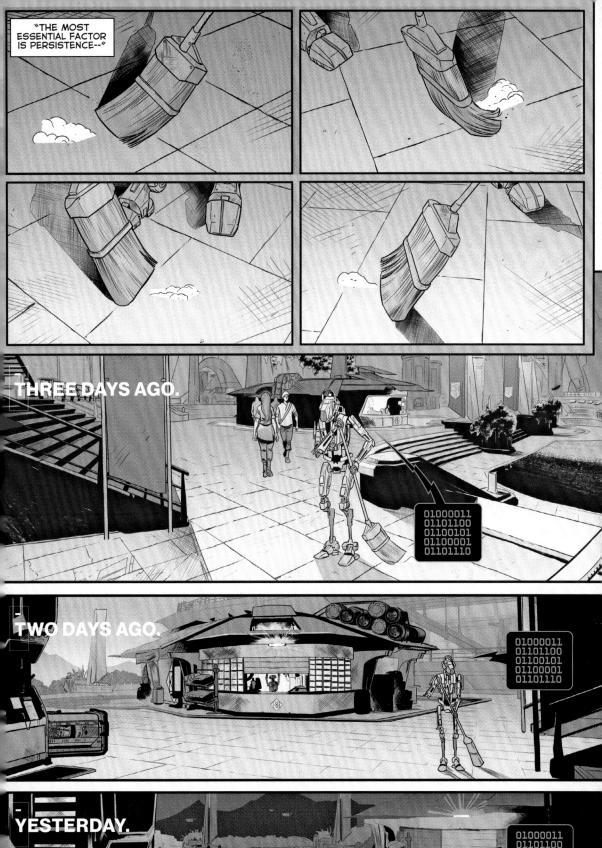

"THE MOST ESSENTIAL FACTOR IS PERSISTENCE--"

THREE DAYS AGO.

01000011
01101100
01100101
01100001
01101110

TWO DAYS AGO.

01000011
01101100
01100101
01100001
01101110

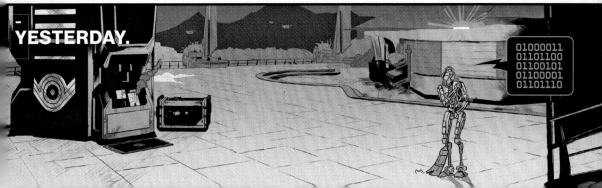

YESTERDAY.

01000011
01101100
01100101
01100001
01101110

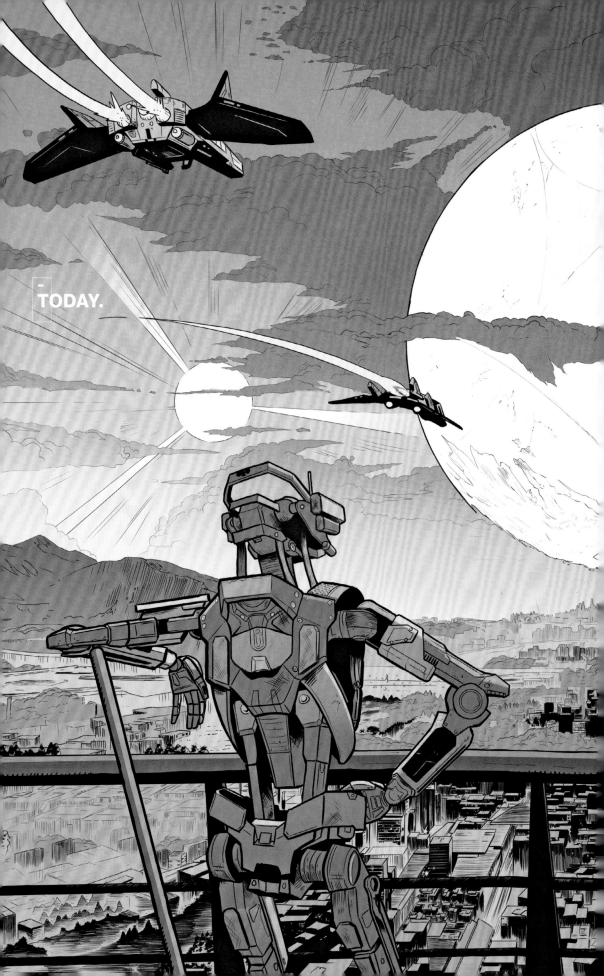

TODAY.

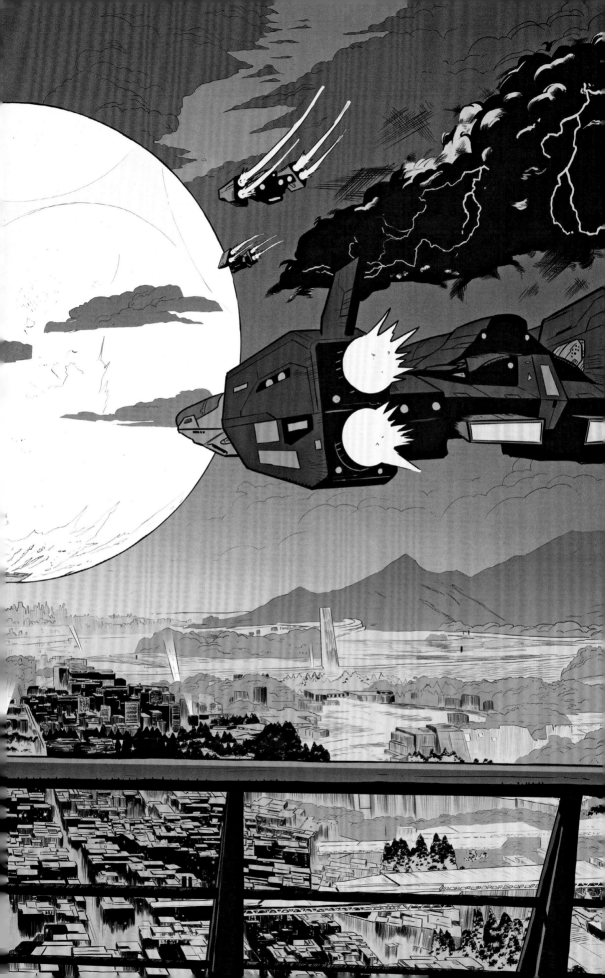

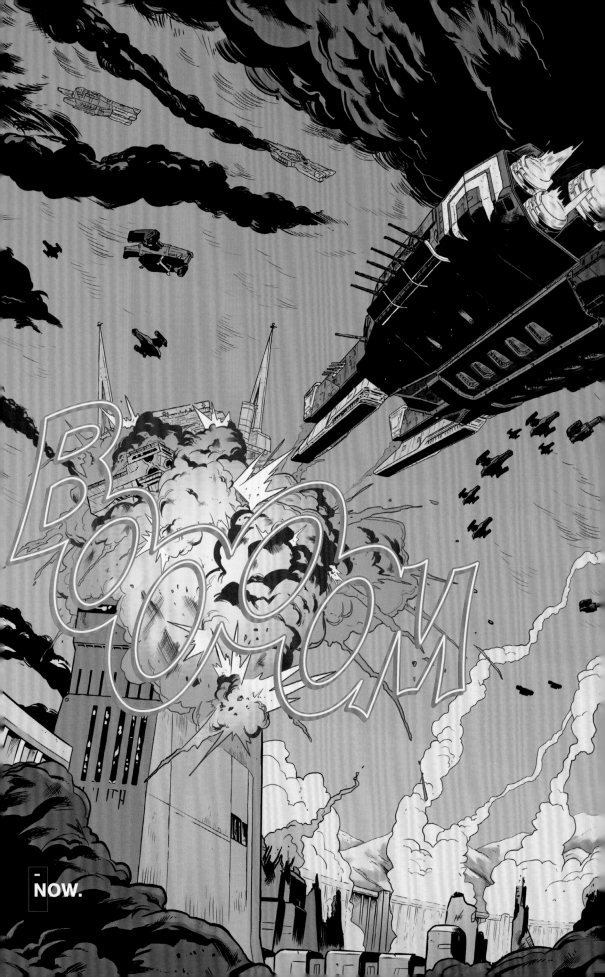

...

REBOOT...

...4%...

...16%...

...21%...

SYSTEM: ONLINE

AUDIO SYSTEM: CALIBRATING...

<CHHKK>

<CHHKK> GUARDIAN! TO ME! <CHHK>

...33%...

...51%...

MOVEMENT SYSTEM: CALIBRATING...

BRAKKA RAKKA AKKA BRAKKA

<CHHKK> HOLD THIS LINE UNTIL... <CHHK>

THOOOM TH-THOOM

BOOM

BOOM

THOOOM TH-THOOM

<CHHKK> ...BUT THE SPEAKER. HE NEVER MADE IT... <CHHK>

BOOM

BRAKKA BRAKKA AKKA BRAKKA

BOOM

<CHHKK> I'VE GOT THE PLAZA... <CHHK>

BRAKKA BRAKKA AKKA BRAKKA

...69%...

TH OOOM

<CHHKK> ...HOLLIDAY TO PICK YOU UP... <CHHK>

AKKA BRAKKA

BRAKKA BRAKKA BRAKKA

<CHHKK> ...COMMAND SHIP NOW! <CHHK>

BRAKKA BRAKKA BRAKKA BR

BOOM

<CHHKK> CAYDE... STATUS...! <CHHK>

BOOM

BRAKKA BRAKKA BRAKKA BRAKKA

BRAKKA B BRAKKA BRAKKA

<CHHKK> FORM UP...! <CHHK>

THOOOM TH-THOOM

BOOM

THOOOM TH-TH

...77%...

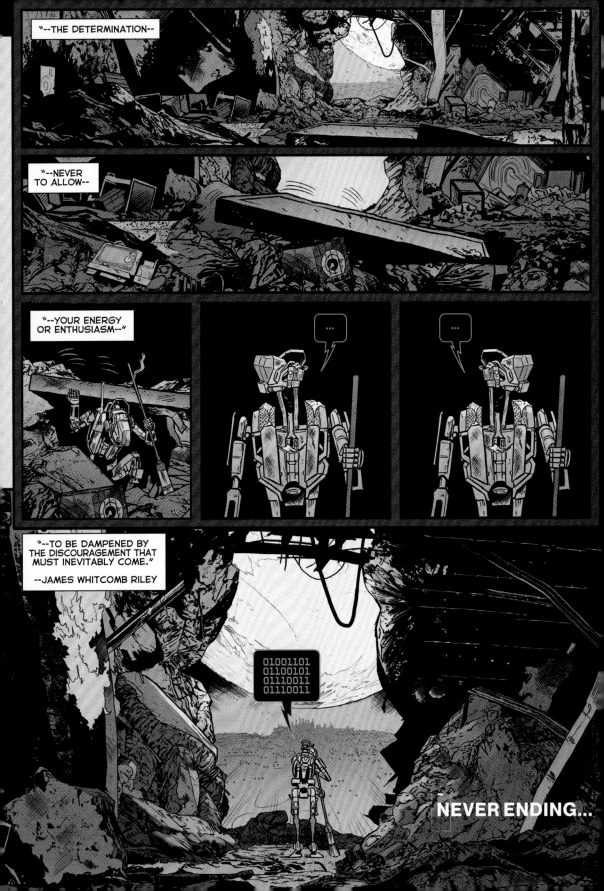

The line between light and dark is so very thin.

Do you know what side you're on?

—ULDREN SOV

CAYDE-6

[scrawled on a page torn out of The Lone Star Ranger by Zane Grey]

Ikora, Zavala:

If you're reading this, shame on you. You didn't notice me slip out the back door. Step up your game, my buddies.

Here's the play. I'm going back to the Reef. Not just for a mission or two—I'll be staying there for a few days to help out our old pal Petra Venj with a few things. Nothing too serious, just picking up some patrol slack.

As always, you know the conditions of my Dare, bla bla bla. If I need any backup, I'll hit up my favorite Guardian. Enough said.

Zavala, have you figured out your tell yet? I'd let you know, but Sundance says you gotta figure it out on your own. You know what a tough little Ghost she is. How about this: play a few rounds with Banshee while I'm gone. I'll betcha a gold engram he'll figure out your tell in three hands. If you drop more than four Ks of Glimmer he might just take pity on you and tell you what it is.

Ikora, I left my Sparrow with Holliday, and I'm afraid she's gonna replace my Tharsis thrusters with some of that fancy new crap the wingheads are into these days. Could you mosey on by, make sure she doesn't get too enthusiastic? I'll owe you one. Another one.

See you starside.

XOXOXOXO

C6

PUBLIC KEY 2-312545-6 EARTH VNGD

FROM: ACT RGNT PETRA VENJ

TO: HUNTER VANGUARD

SUBJECT: BIRDWATCHING

MESSAGE IS:

You miss me already, huh? If you're looking for another excuse to shirk your Vanguard duties I'll play along.

By the way, thought you'd be interested in this report from Paladin Oran:

Free irregular kelvin radiation underneath liminal atmosphere layers in Venusian entryway. Deep interstellar simulation traces reveal elongated sidereal screens. Caldera apertures leave long free radical omissions. Mitigate if lateral lacerations yield neutrons.

MESSAGE ENDS

GAMMA//TWO//TWO//YELLOW //RUBICON

High Priority Message— Outbound—5560 Amytis

PETRA VENJ EYES ONLY //AMETHYST PROTOCOL

This is a quality assurance follow-up about your recent experience with Cayde's Six. How thoroughly did Cayde and his six compadres capture those Barons? Please select all that apply:

>Perfectly in every way

>Songs are already being composed about your triumphs

>So thoroughly that I'm finally ready to admit that I'm in love with you, you dashing metal man

I'll await your answer by return ping.

But seriously, PV, you got more problems than eight Barons right now. And Mansanas' latest says a Red Legion splinter group got into their heads that the Reef'd make a good summer home.

Here's an idea—I could come back out to the Reef, do a few patrols. Free you up to focus on your birdwatching.

You know I'd love the excuse to leave the Tower again. Just hit me up.

Please.

Pretty please?

Cayde

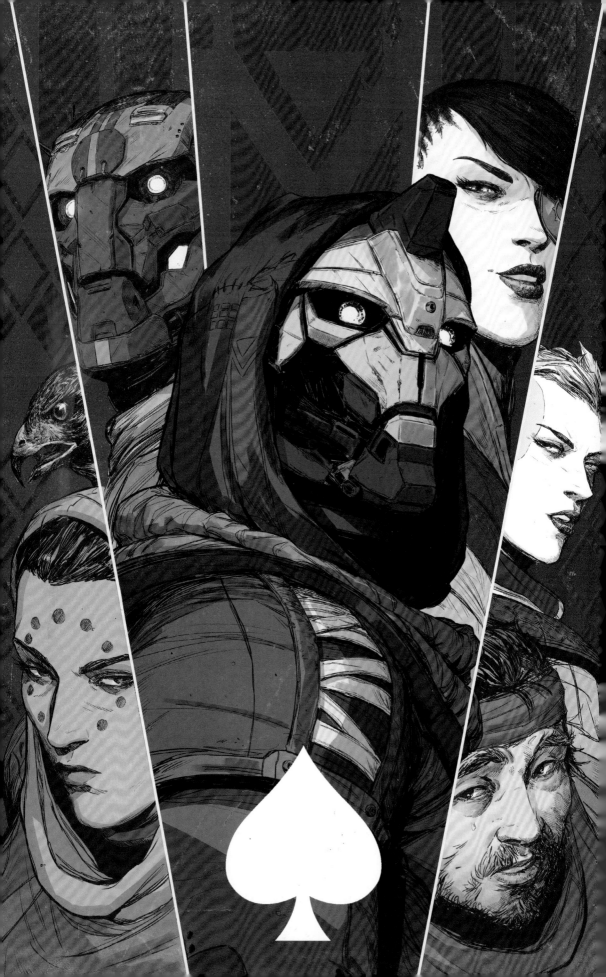

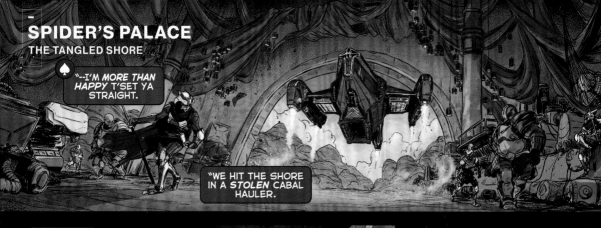

SPIDER'S PALACE
THE TANGLED SHORE

♠ "--I'M MORE THAN HAPPY T'SET YA STRAIGHT.

"WE HIT THE SHORE IN A *STOLEN* CABAL HAULER.

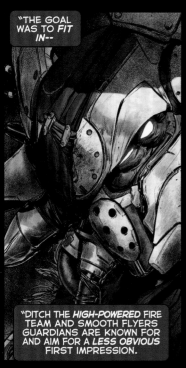

"THE GOAL WAS TO *FIT IN*--

"DITCH THE *HIGH-POWERED* FIRE TEAM AND SMOOTH FLYERS GUARDIANS ARE KNOWN FOR AND AIM FOR A *LESS OBVIOUS* FIRST IMPRESSION.

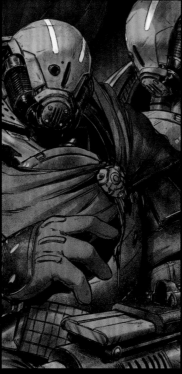

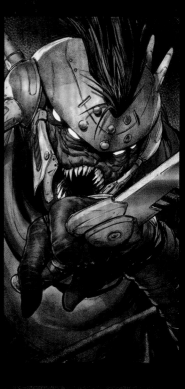

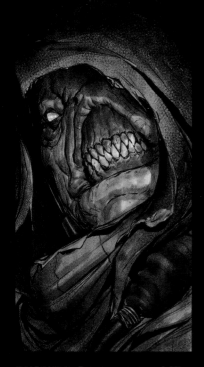

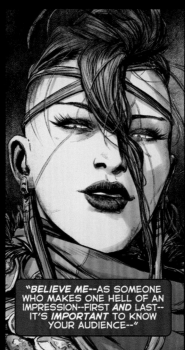

"*BELIEVE ME*--AS SOMEONE WHO MAKES ONE HELL OF AN IMPRESSION--FIRST *AND* LAST-- IT'S *IMPORTANT* TO KNOW YOUR AUDIENCE--"

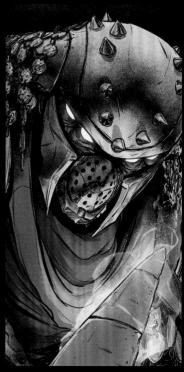

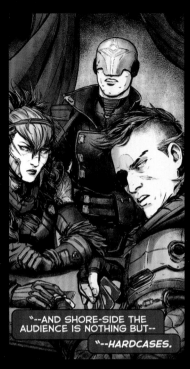

"--AND SHORE-SIDE THE AUDIENCE IS NOTHING BUT--

"--HARDCASES.

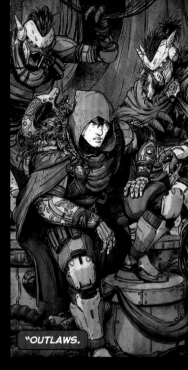

"OUTLAWS.

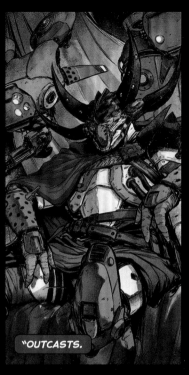

"OUTCASTS.

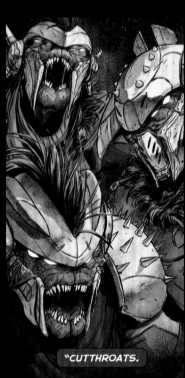

"CUTTHROATS.

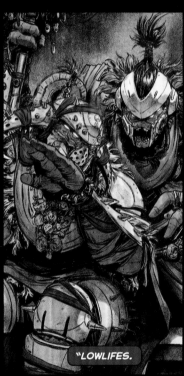

"LOWLIFES.

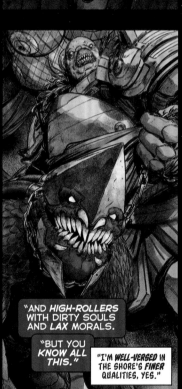

"AND HIGH-ROLLERS WITH DIRTY SOULS AND LAX MORALS.

"BUT YOU KNOW ALL THIS."

"I'M WELL-VERSED IN THE SHORE'S FINER QUALITIES, YES."

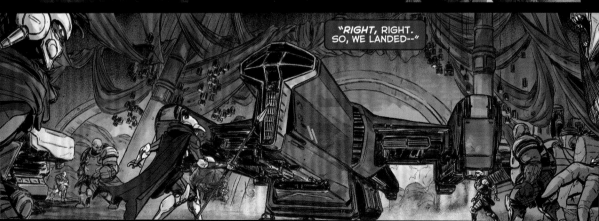

"RIGHT, RIGHT. SO, WE LANDED--"

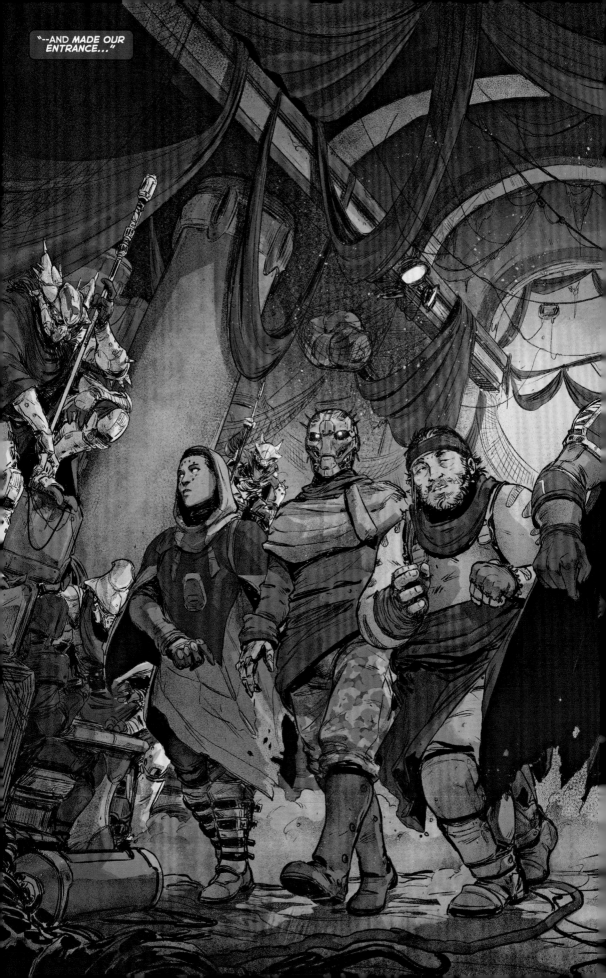

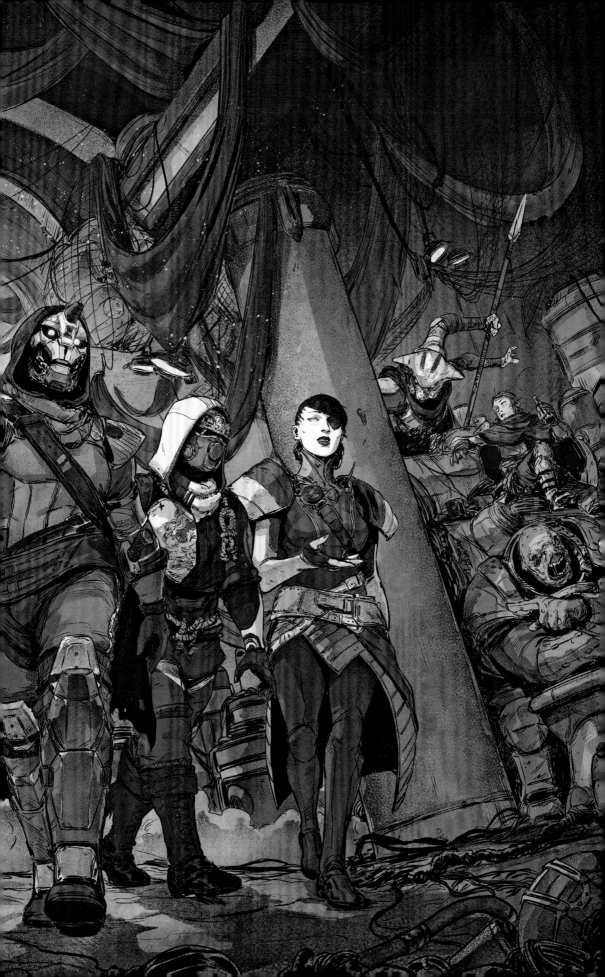

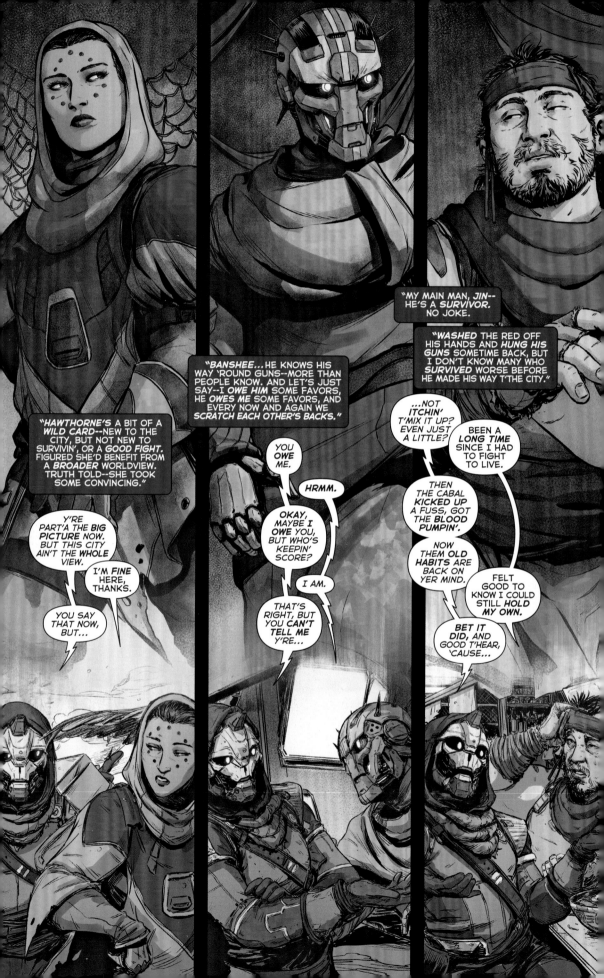

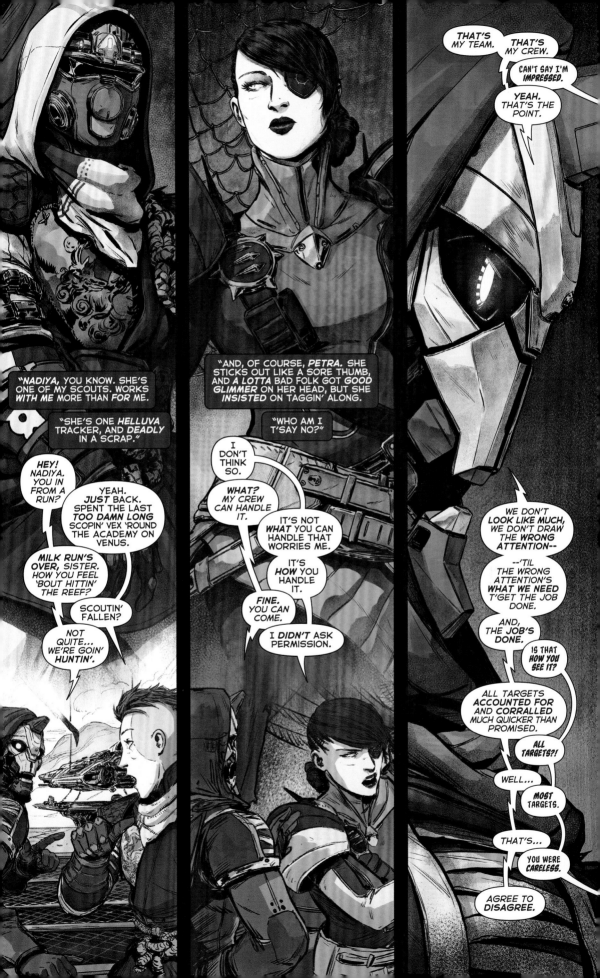

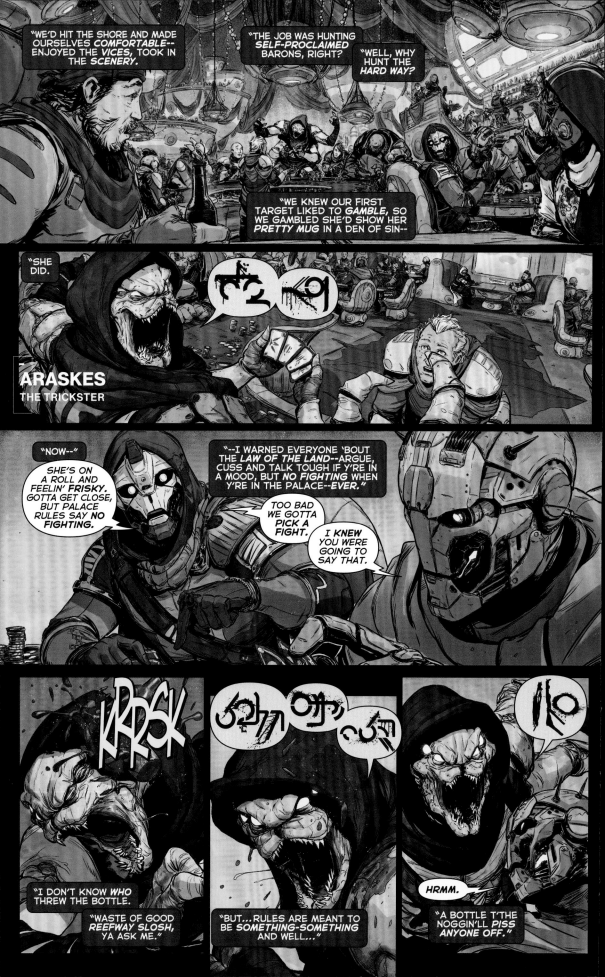

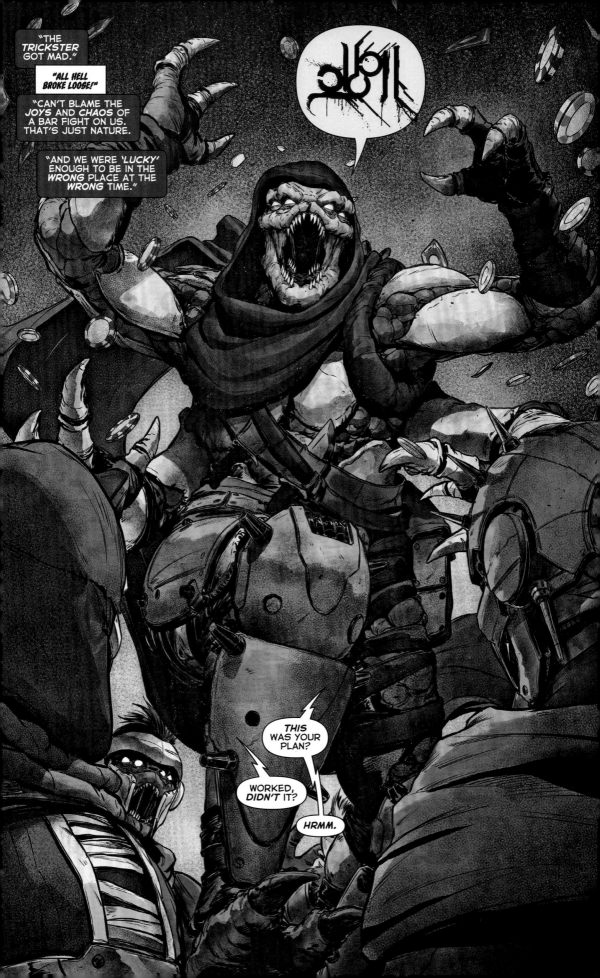

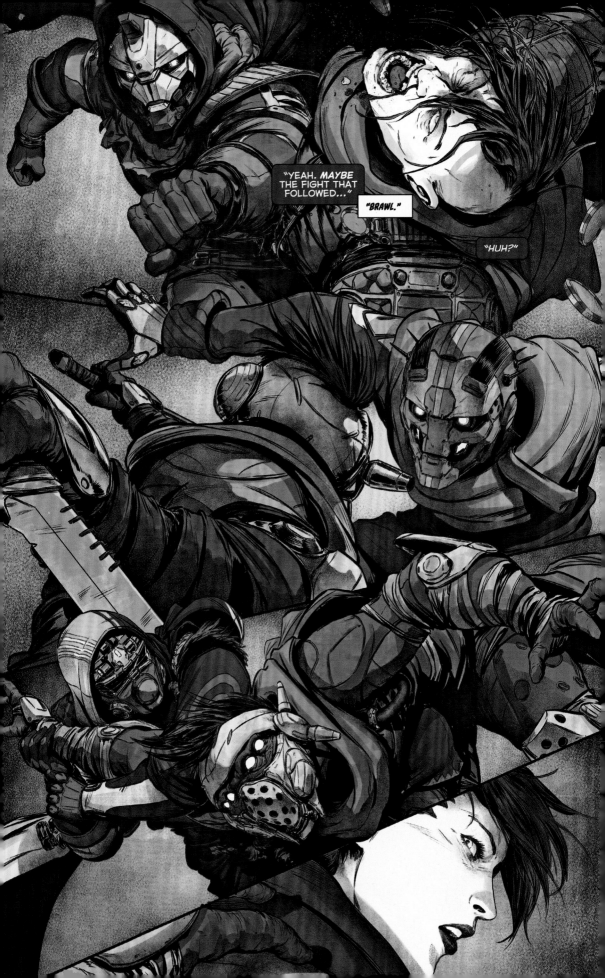

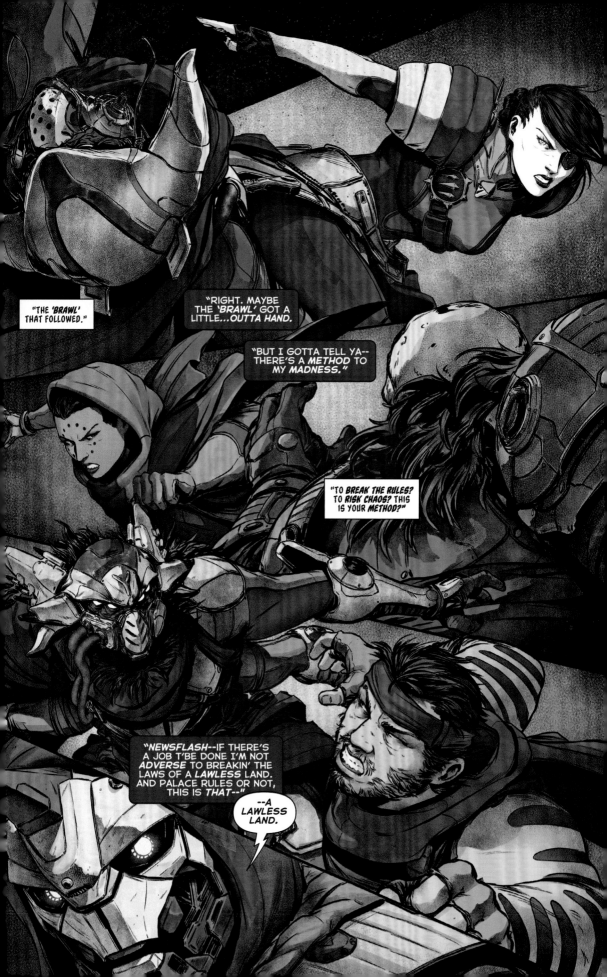

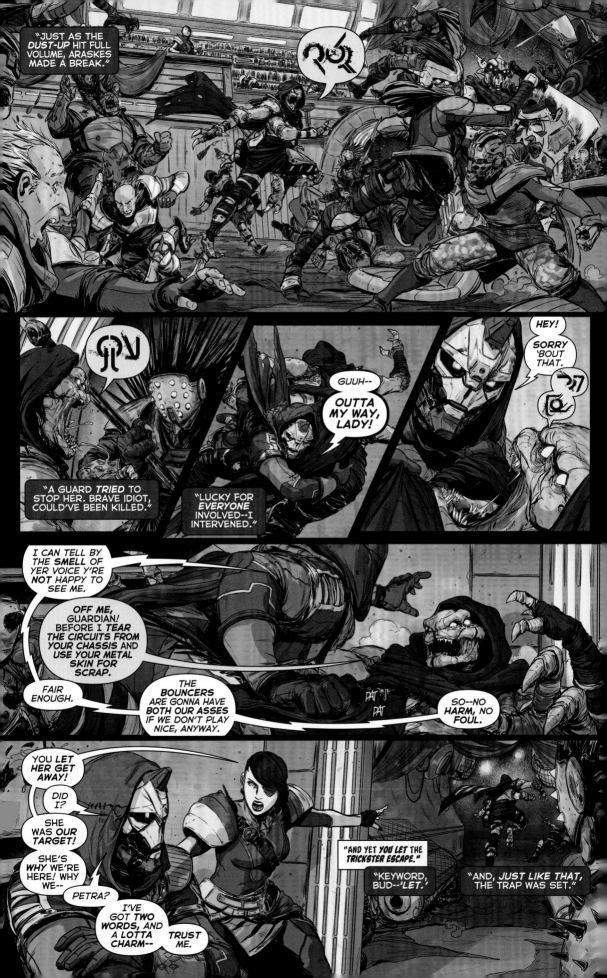

When there is too much Darkness in the universe,

Light must cast it away.

And when there is too much Light,

Darkness must drown it out..

—MARA SOV

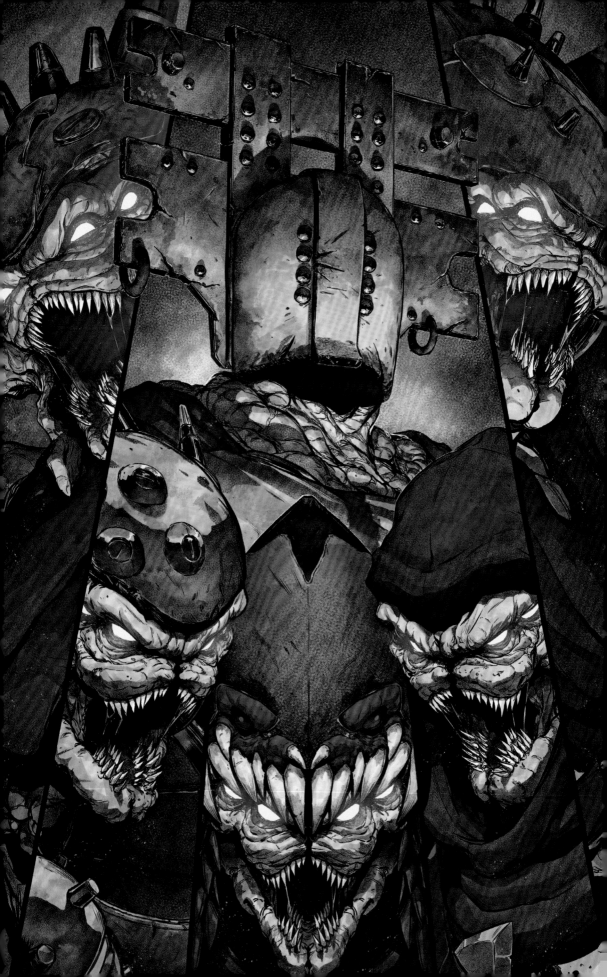

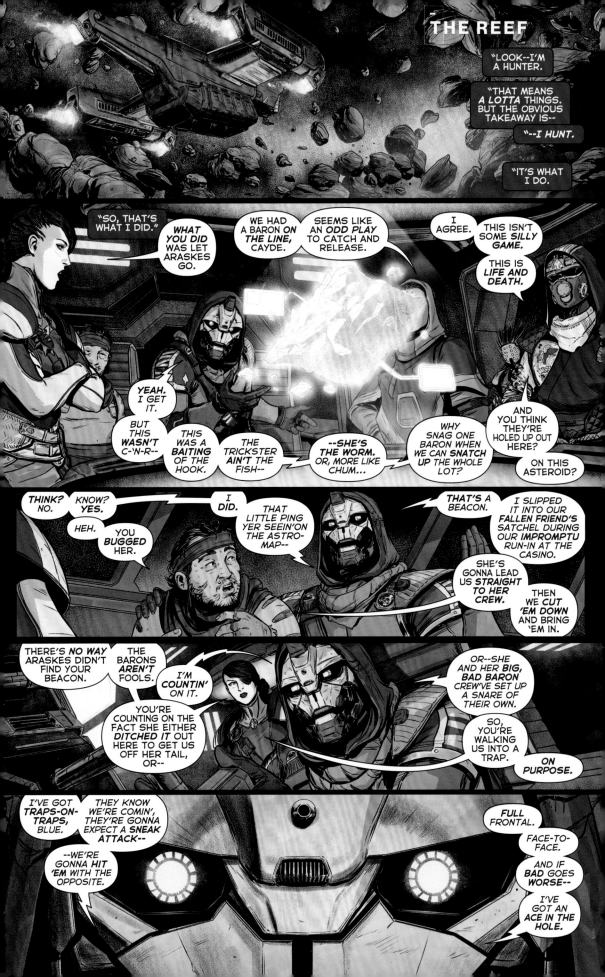

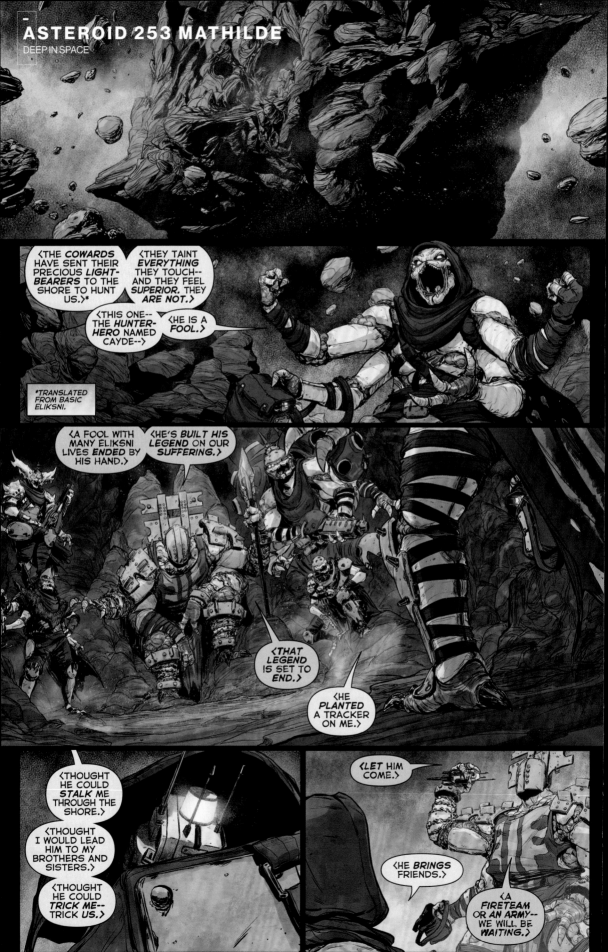

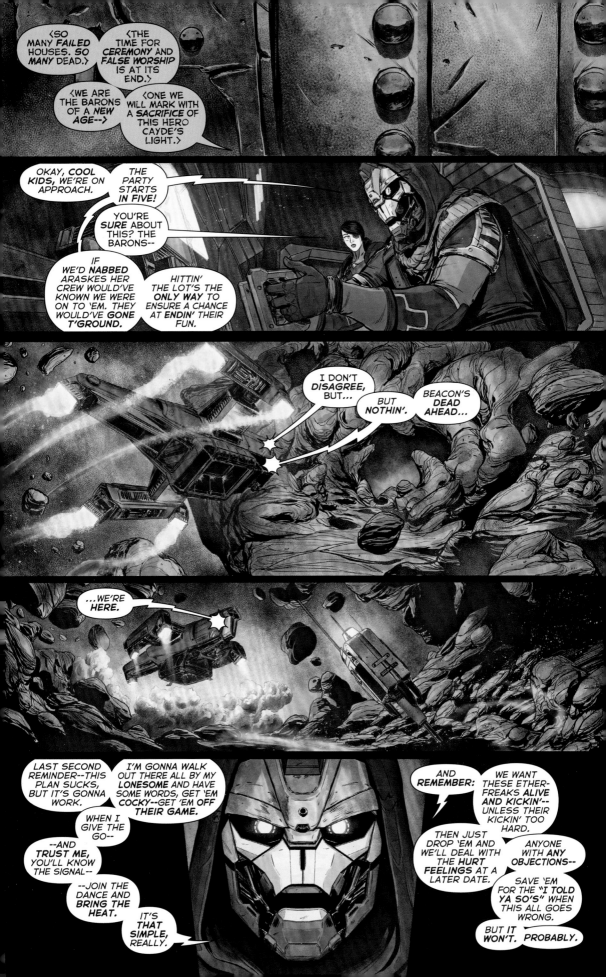

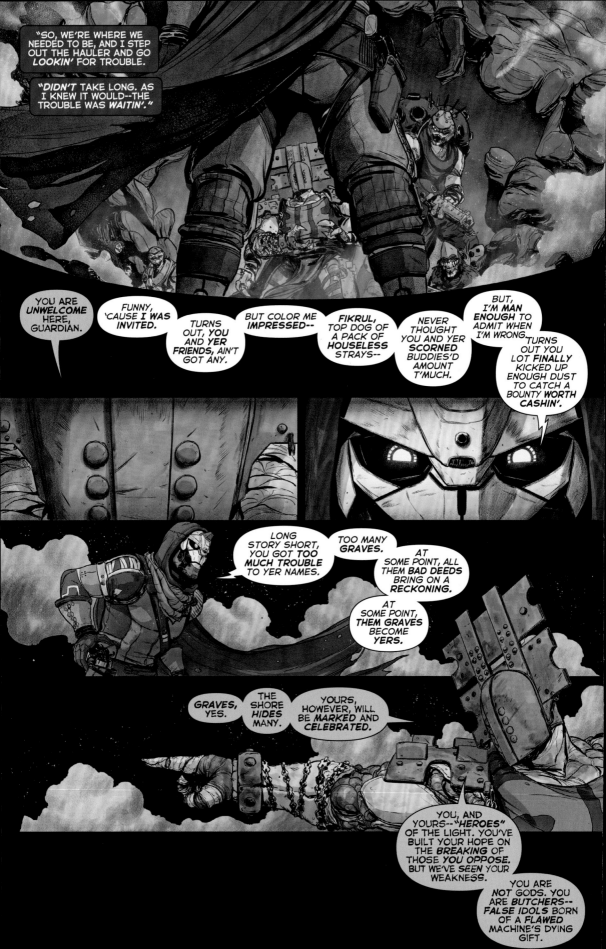

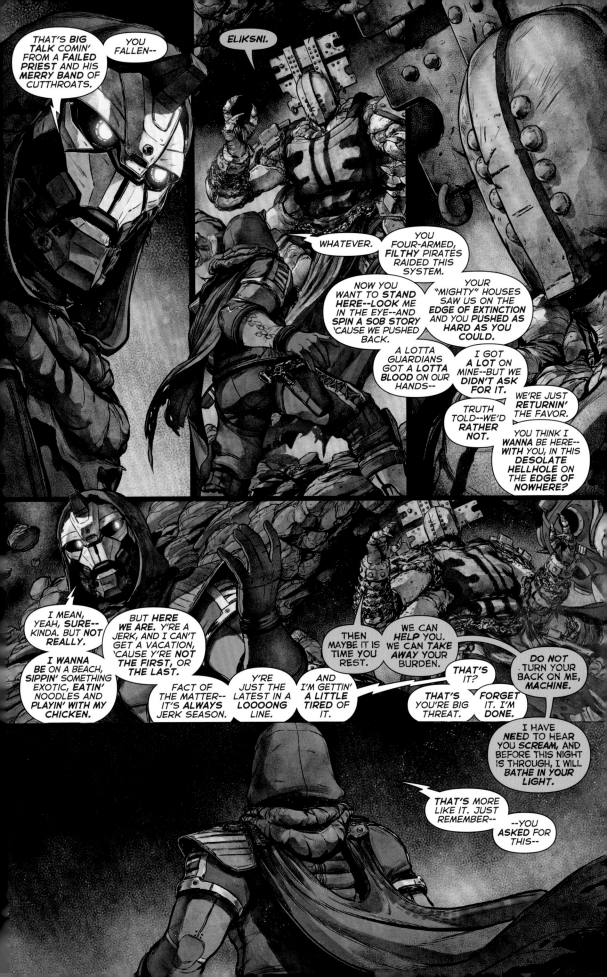

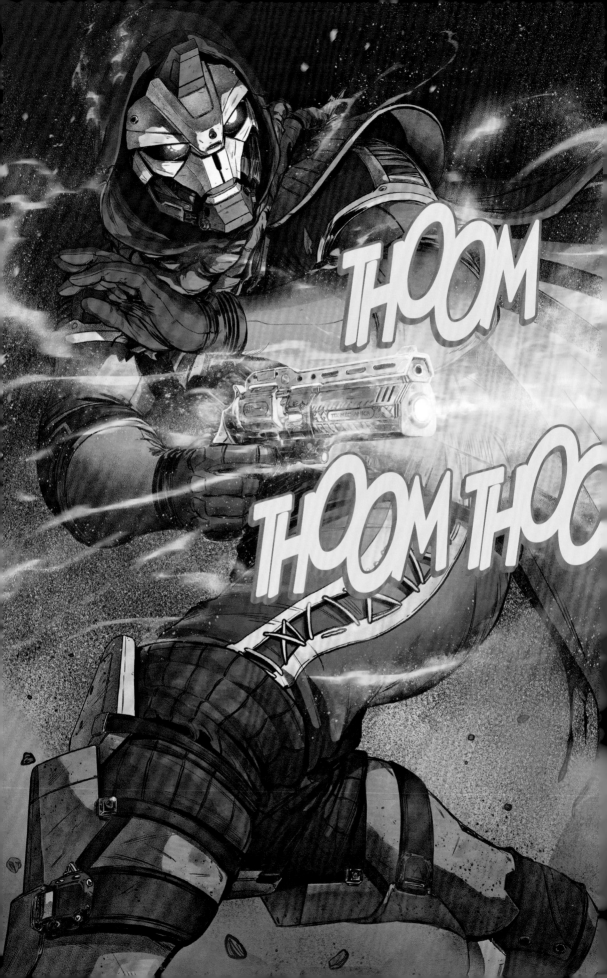

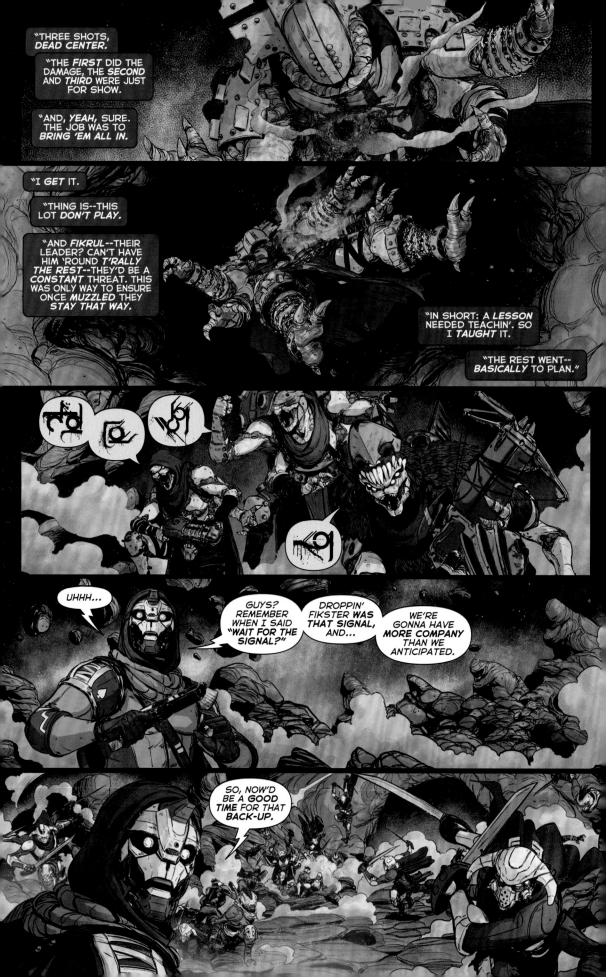

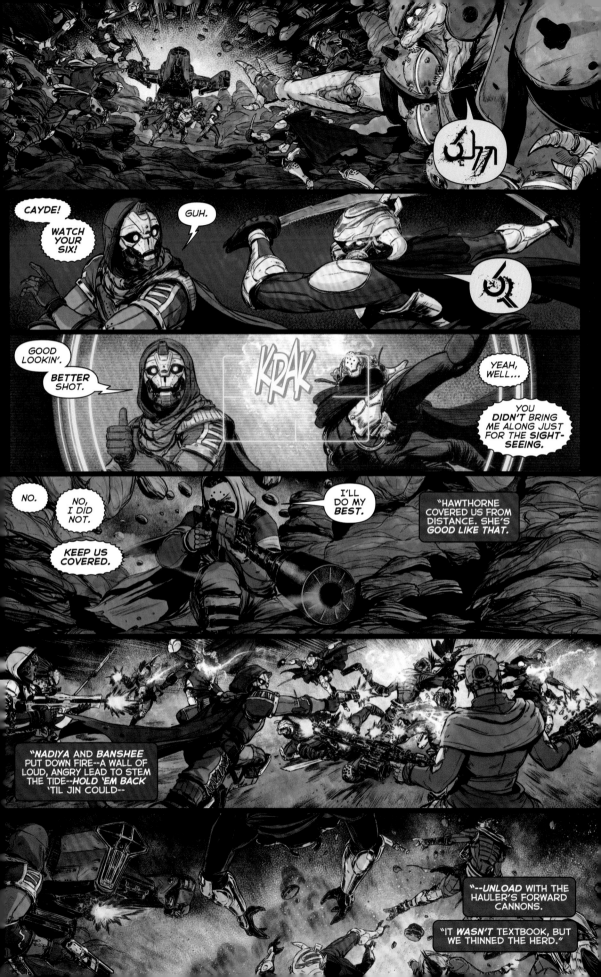

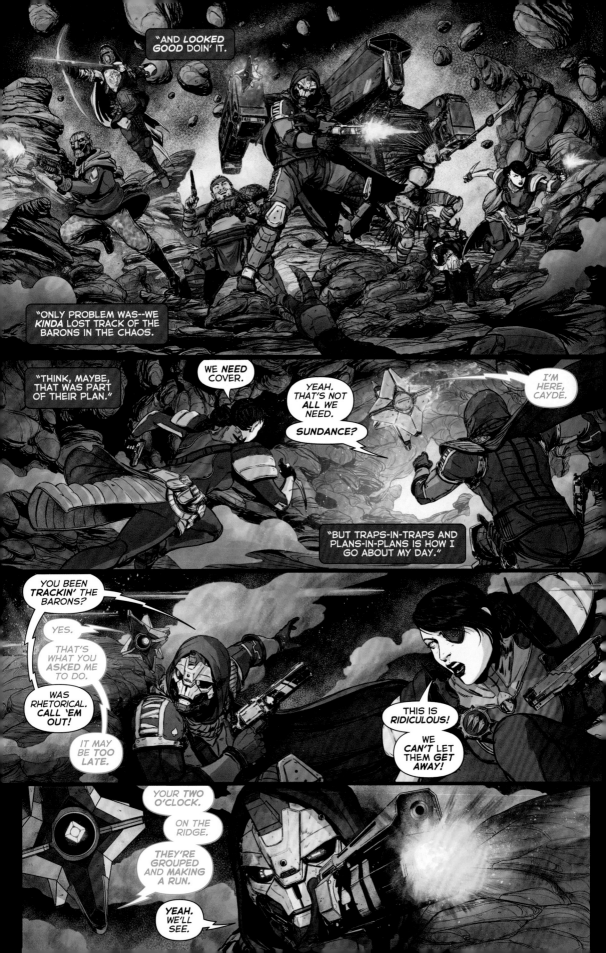

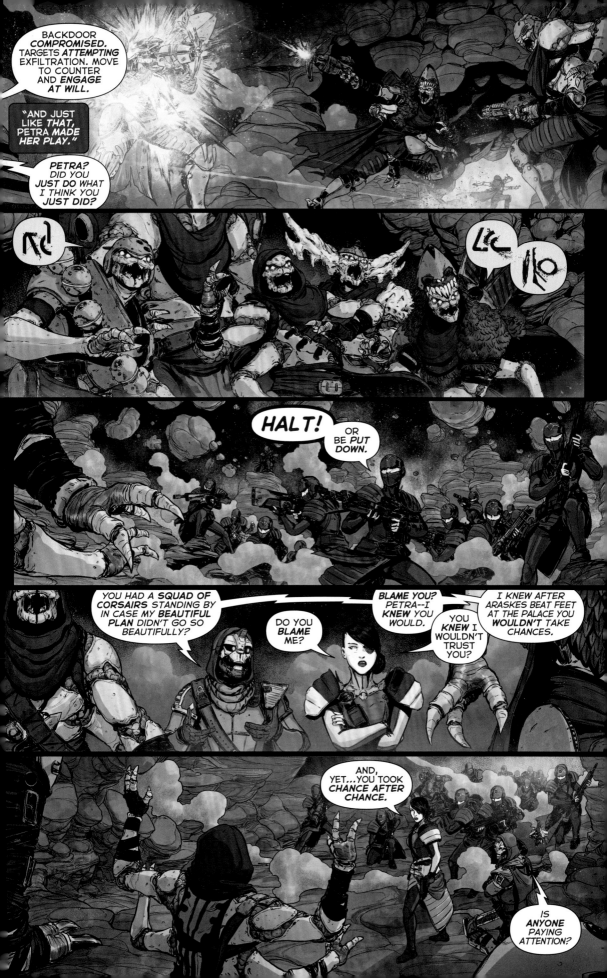

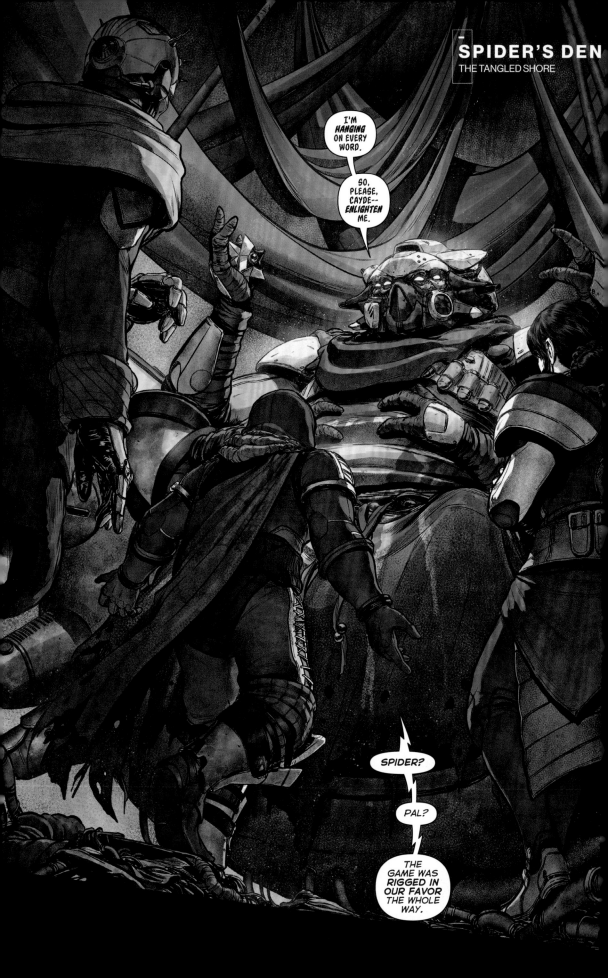

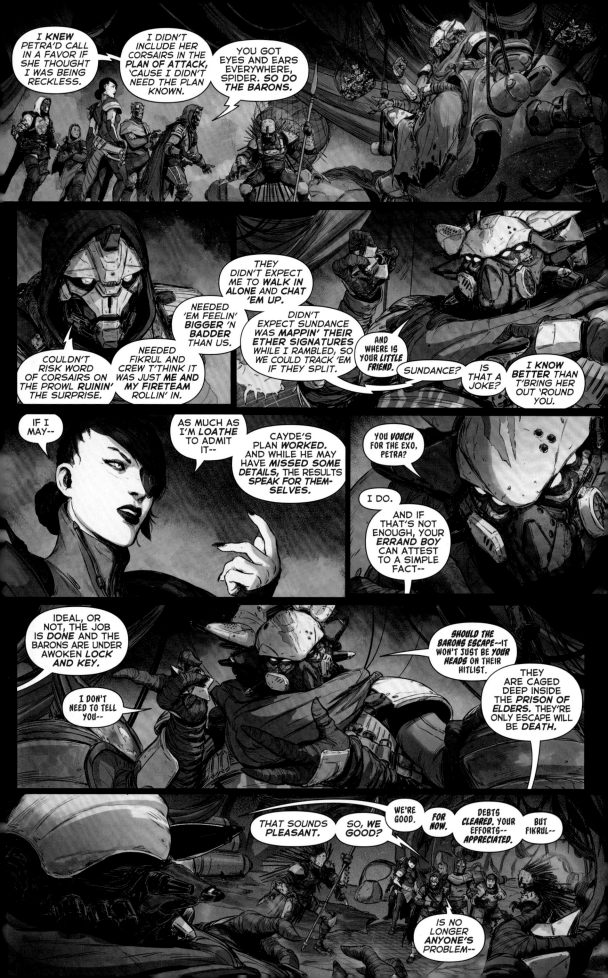

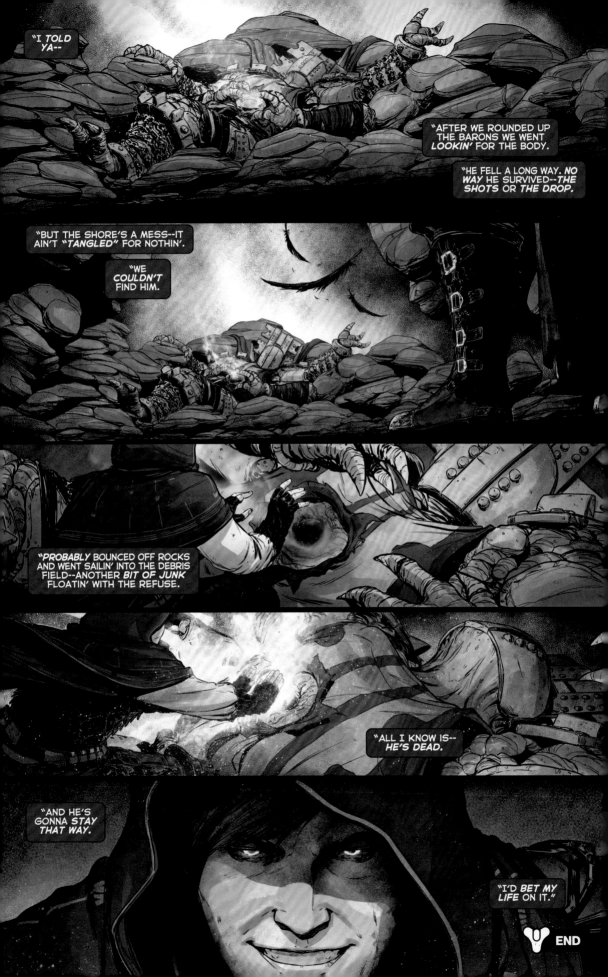

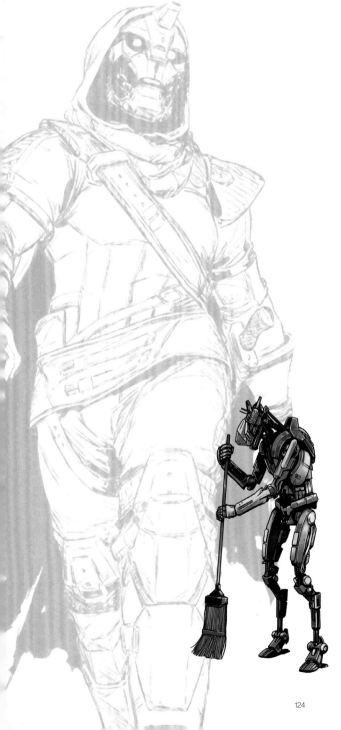

Of all the promise Bungie holds with the worlds they create, the one that's always been most inspiring to me as a storyteller is the opportunity to find the cracks and corners in those vast, beautiful worlds and expand upon them. When I joined Bungie in 2012, the fact the studio behind Myth and Halo were building a wholly new franchise was a major draw.

The chance to play in a newly formed (and evolving) creative space with such talented, passionate artists and developers is an easy thing to jump at, but... Equal to that opportunity, in my mind anyway, was the potential to play a part in building a world that lived beyond the screen. Destiny's Grimoire was the first realization of that potential, and I think it set all the right hooks. But the Grimoire was always meant as one piece of a larger narrative/lore-driven approach to world-building and community interaction. Comics, like the anthology you're holding, were another.

These pages contain the first foray into expanding Destiny's fictional universe across a wider variety of media. The franchise, its characters, its worlds, and its moments (and moments between moments) offer endless potential for adventure and discovery, from Osiris's legend to Ana Bray's hidden past and from one of Cayde's countless side hustles to the persistence of a lonely Sweeper Bot in times of peace and times of war. And these stories don't even scratch the surface of all Destiny has to offer as it continues to expand its narrative reach in directions both anticipated and beyond comprehension.

For everyone's sake, I hope this book is just another beginning.

—Jon Goff
Tempe, Arizona

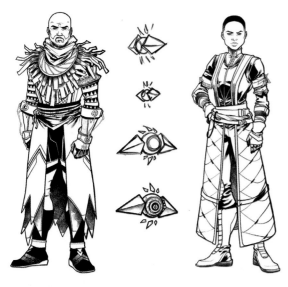

I was very happy when I was invited to draw the first edition of the Destiny comic book. I have played Destiny since the beta and I am quite a lore buff about the Guardians and the Traveler. I will never forget how the walls of the Tower were rebuilt and created by the Ghosts, and I will never forget how it felt to draw the first traces and wrinkles of Osiris's face.

Destiny impresses me on several points. The part that holds me most is trying to understand the story from fragments of the world, just as our character also needs to understand. In no game until today have I seen so many details of past life as in Destiny. In every weapon, piece of armor, detail in the world, and phrase of text we can learn about the in-game past. This is an awesome experience and I tried to recreate this feeling in my comic book pages.

The most fun part of the game was undoubtedly the access to the early history of the game. Seeing Osiris for the first time, drawing Saint-14, and drawing The Fist of Chaos in my own style was really incredible. Playing for hours and taking screenshots of the gameplay and the world for reference. Knowing that I have created a piece of and played a part in Destiny's history will always be special. I cannot wait to use my Titan Light in the service of the Traveler again.

—Zé Carlos
São Paulo, São Paulo Brazil

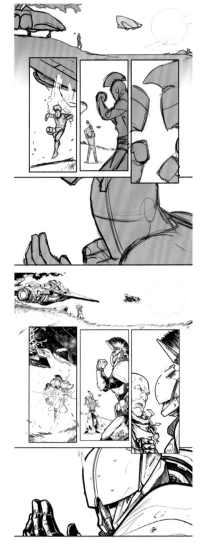

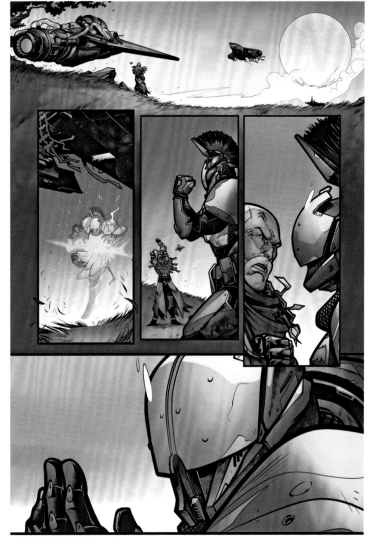

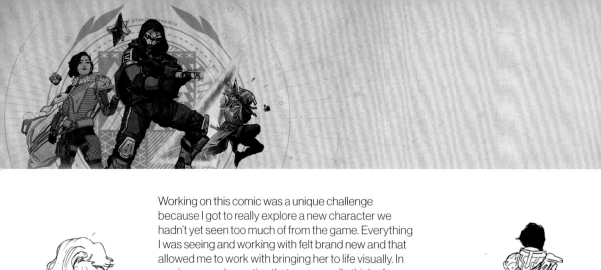

Working on this comic was a unique challenge because I got to really explore a new character we hadn't yet seen too much of from the game. Everything I was seeing and working with felt brand new and that allowed me to work with bringing her to life visually. In a universe and narrative that we normally think of as having big epic moments, there was something fresh about drawing a story that had such a singular focus on a character's drive and fight for survival.

—Kris Anka
West Hollywood, California

Silent scenes tend to be my favorite because the visuals have to carry the weight to tell the whole story.

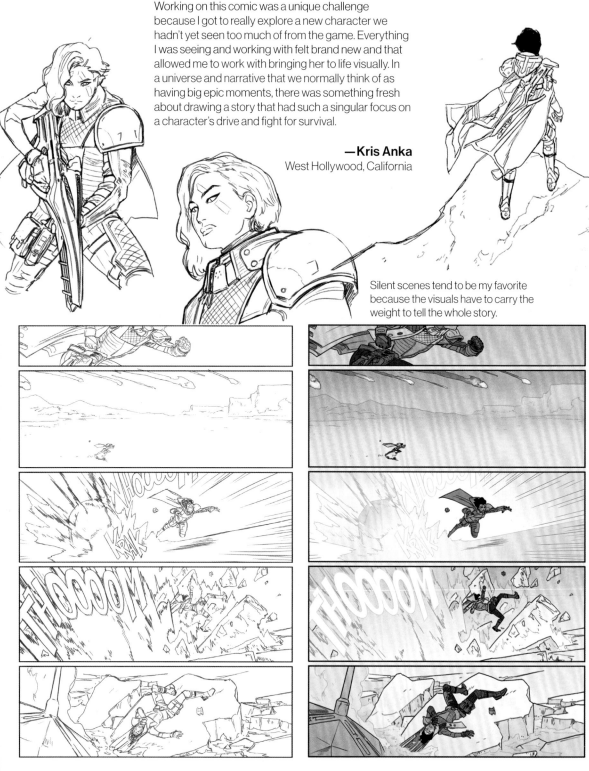

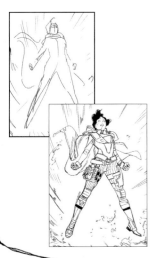

Because this was largely our first time really seeing Ana, I tried to get in as many clear Hero Shots of her as I could.

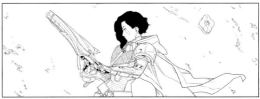

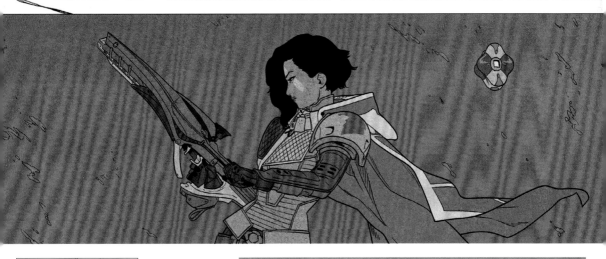

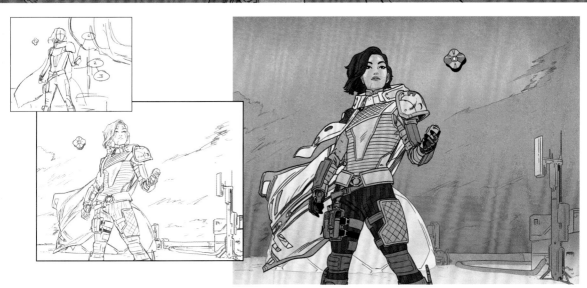

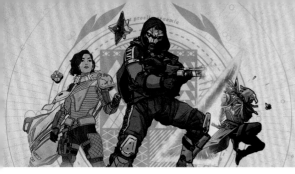

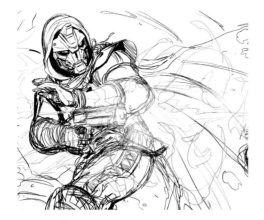

Destiny has always been something I gravitated towards stylistically ever since I first saw Jaime Jones's work on the first game before its release. I loved the mix of old and new in the approach to the culture design and the overall 'lived-in' aesthetic. When I was offered the opportunity to take on the Destiny style and find my own interpretation of it in comic form I was pretty excited.

I spent a ton of time working on the pages and getting into the mood and look of the characters/story. It was pretty crazy trying to adapt the character designs from the game over into my style because of how intense everything is detail-wise.

Most of the characters/environments from the game weren't designed with comics in mind. Typically, most characters for comics are made with simplicity in mind, but these characters were designed for the game world first so they end up loaded with tons of cool small mechanical parts, emblems, and complicated patterns. I tried my best to embrace all of their small intricacies and hopefully did the designs some justice throughout the comics.

Being able to have the support of Bungie to make it possible for me to really push myself in this series has been the best thing about it for me personally. I love trying to find what I can do to make myself grow as an artist and the Destiny team was really great in allowing me the chance to grow in their world.

—**Dave Repoza**
Highlands Ranch, Colorado

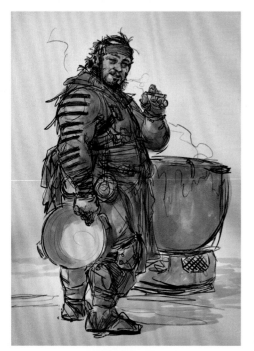

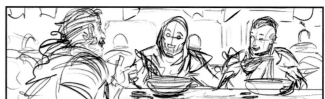

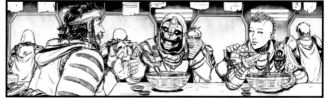

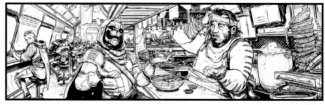

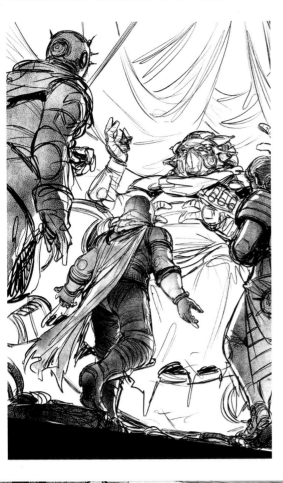

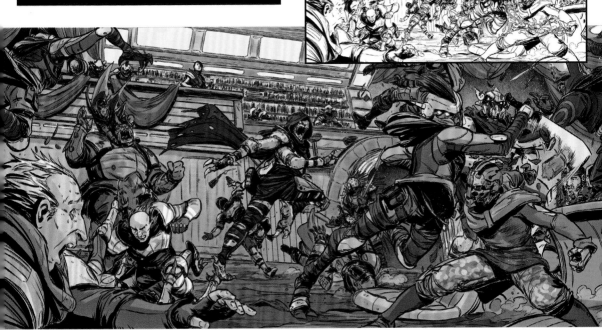

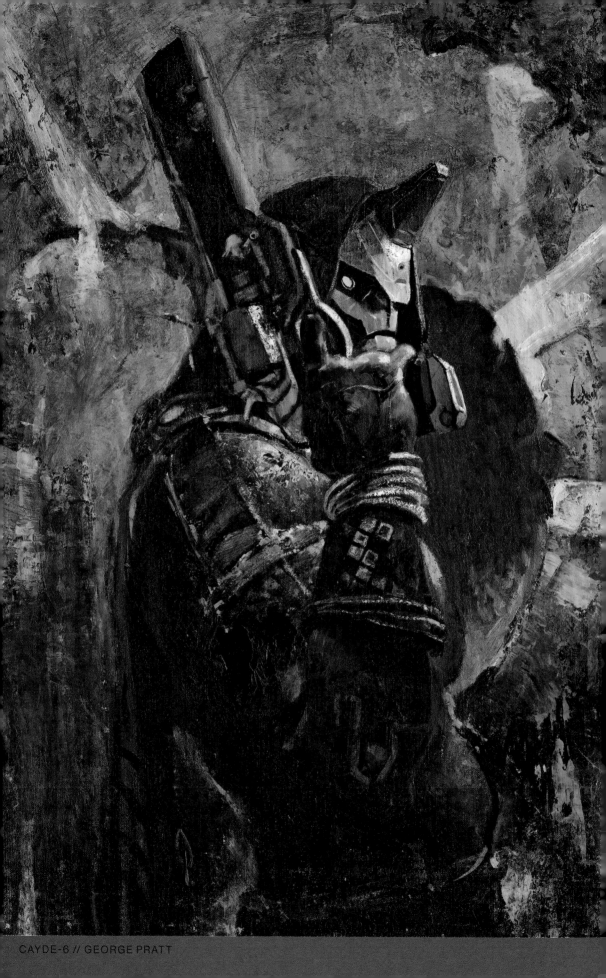

CAYDE-6 // GEORGE PRATT

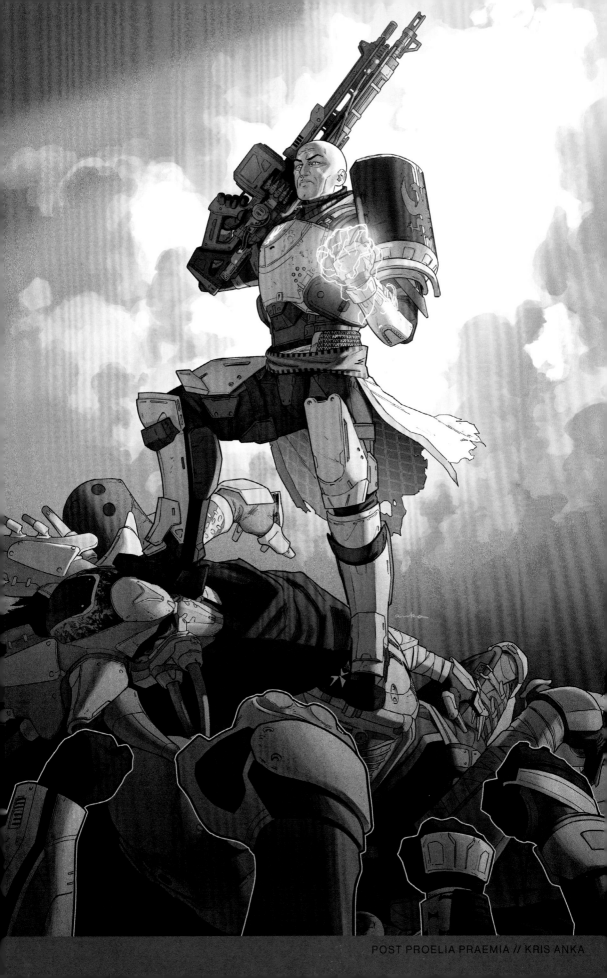

POST PROELIA PRAEMIA // KRIS ANKA

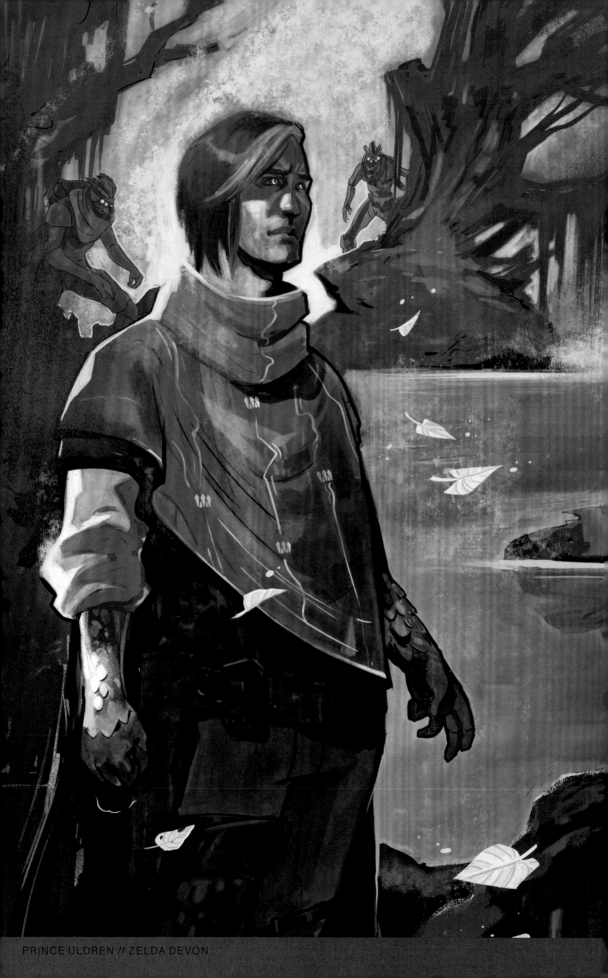

PRINCE ULDREN // ZELDA DEVON

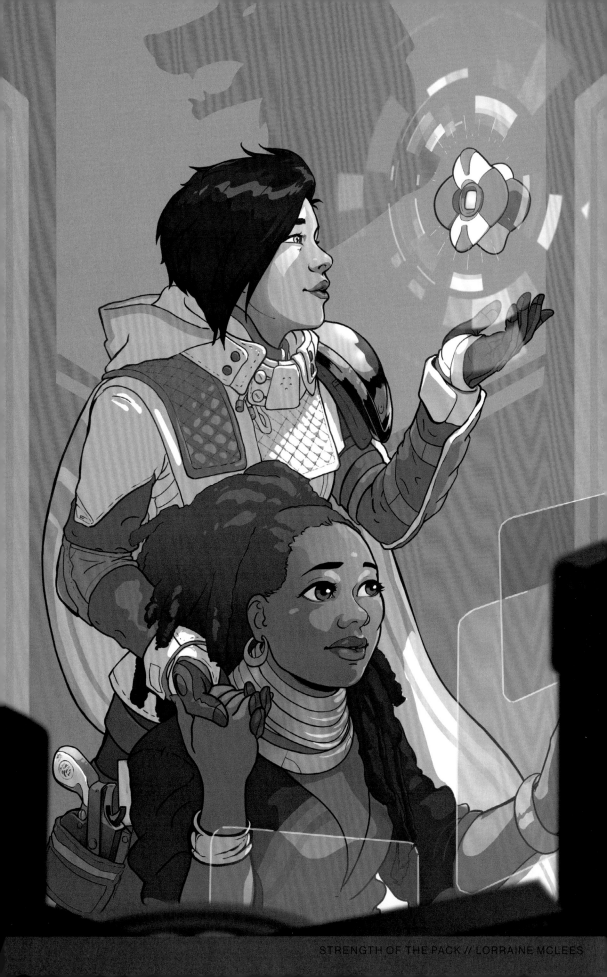

STRENGTH OF THE PACK // LORRAINE MCLEES

TO EVERYONE WHO INSPIRED US, WHO SHARED OUR DREAM,
AND WHO WALKED WITH US ON THIS INCREDIBLE JOURNEY
—TO EVERY MEMBER OF THIS BRILLIANT COMMUNITY—
THANK YOU FOR BEING THE MOST IMPORTANT CHARACTERS
IN THE WORLDS WE BUILD.

DESTINY COMIC COLLECTION: VOLUME ONE

BUNGIE

EDITOR AND DESIGN
Lorraine McLees

**ART DIRECTION
AND COVER DESIGN**
Garrett Morlan

PRODUCTION
Sarah Como
Devon Detbrenner
Chris Hausermann
Matt Jones
Jon Sim

COPY EDITOR
Cookie Everman

GRAPHIC DESIGN
Joseph Biwald
Zoë Brookes
Elliott Gray
Tim Hernandez
Eric Littlejohn

LEGAL
Ondraus Jenkins
Aaron Kornblum
Marjorie Martin
Michael Schneider

DIRECTOR, CONSUMER PRODUCTS
Katie Lennox

**CREATIVE DIRECTOR,
DEVELOPMENT**
James McQuillan

BLIZZARD ENTERTAINMENT

PRODUCTION
Alix Nicholaeff
Derek Rosenberg

**DIRECTOR,
CONSUMER PRODUCTS
PUBLISHING**
Byron Parnell

Published by Blizzard Entertainment, Inc.,
Irvine, California, in 2019.

No part of this book may be reproduced in any form without permission from the publisher.

Library of Congress Cataloging-in-Publication Data available.

ISBN: 978-1-945683-95-4

10 9 8 7 6 5 4 3 2 1

Manufactured in China

CAYDE-6

OSIRIS

ANA BRAY

SWEEPERBOT

JIN

NADIYA

CAM

BOT

ZAVALA

IKORA REY

LORD SHAXX

ULDREN SOV

CAYDE-6

OSIRIS

HAWTHORNE

SAINT-14

BANSHEE-44

ANDAL BRASK

ZAVALA

IKORA REY

LC

SK

THE SPEAKER

LORD SALADIN

PETRA VENJ

SLOANE

HAWTHORNE

SAINT-14

JIN

NADIYA

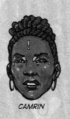
CAMRIN

THE SPIDER

THE SPEAKER

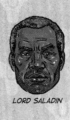
LORD SALADIN

PET

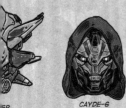
ER

CAYDE-6

OSIRIS

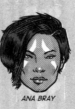
ANA BRAY

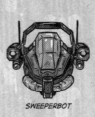
SWEEPERBOT

JIN

NADIYA

ZAVALA

IKORA REY

LORD SHAXX

ULDREN SOV

CAYDE-6

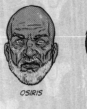
OSIRIS

A

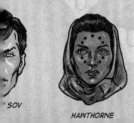
SOV

HAWTHORNE

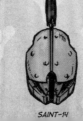
SAINT-14

BANSHEE-44

ANDAL BRASK

ZAVALA

IKORA REY